ULRICH KELLER

THE BUILDING
OF THE
PANAMA CANAL
in Historic Photographs

Dover Publications, Inc., New York

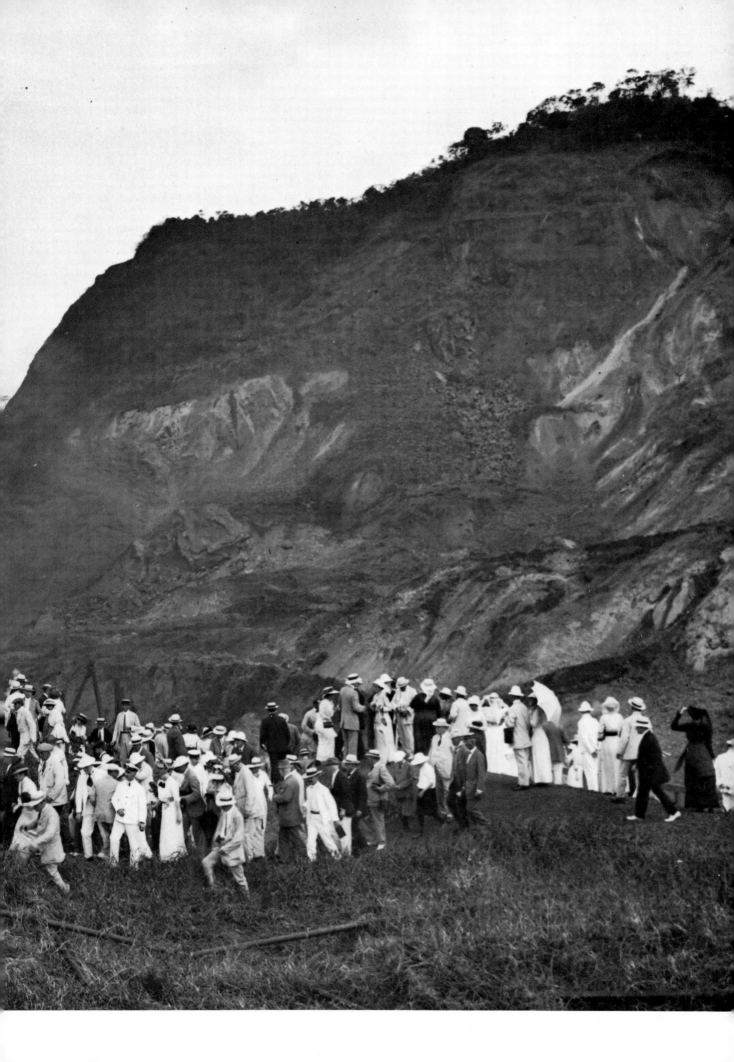

Bibliographical Note

The Building of the Panama Canal in Historic Photographs is a new work, first published by Dover Publications, Inc., in 1983.

Book design by Barbara Effron

Library of Congress Cataloging-in-Publication Data

The Building of the Panama Canal in historic photographs.
 ISBN-13: 978-0-486-24408-2
 ISBN-10: 0-486-24408-3
 1. Panama Canal (Panama)—History—Pictorial works. I. Keller, Ulrich, fl. 1977—
TC774.B86 2008
627'.137'0972875—dc22

82-9543

Manufactured in the United States of America
Dover Publications, Inc., 31 East 2nd Street, Mineola, N.Y. 11501

Introduction

Ever since 1513, when Balboa discovered the Pacific behind the narrow land bridge connecting the continents of North and South America, men dreamed of building a canal to join the two oceans.[1] Holy Roman Emperor Charles V entertained the idea quite seriously, and ordered a land survey in the Panama region to explore the feasibility of an artificial waterway. But it was determined that the difficulties of the project far exceeded the technical resources of the time. Moreover, the piercing of the Isthmus appeared to many contemporaries as such a bold, if not blasphemous, proposition that a Jesuit scholar felt compelled to utter the warning:

> I believe there is no humaine power able to beate and breake downe those strong and impenetrable Mountains, which God hath placed betwixt the two Seas, and hath made them most hard Rockes, to withstand the furie of two Seas. And although it were possible to men, yet in my opinion they should fear punishment from heaven, in seeking to correct the workes, which the Creator by his great providence hath ordained and disposed in the framing of this universall world.[2]

Considerations of this nature put the canal question to rest for two hundred years. Only in the nineteenth century, the age of scientific and industrial progress, did the spirit of enterprise begin to outweigh the fear of God and the menace of physical obstacles. Beginning with Alexander von Humboldt, various explorers toured the Isthmus, searching for an ideal canal location and making a variety of proposals.

The man who finally chose Panama as the most appropriate site and tackled the enormous financial and technical problems involved in an enterprise of such magnitude seemed to be predestined for the job. Ferdinand de Lesseps had done the impossible before—he had completed the celebrated Suez Canal in 1869—and he declared that the mountains of Panama represented a less formidable foe than the Egyptian desert. He even insisted on the practicability of a sea-level canal as opposed to a more modest lock canal.

Thanks to his reputation (and to enormous bribes paid to bankers, politicians and newspapers), Lesseps was able to raise an initial capital of 300 million francs ($60 million). In January 1881, an advance party of French engineers arrived on the Isthmus, followed by an ever-increasing stream of workers and machinery. By May 1884, the labor force had swollen to a total of 19,000 men. But progress was much slower than expected. As it turned out, Lesseps' assessment of the geographical conditions and the technical as well as financial means necessary to overcome them had been grossly inadequate. The mountain range at Culebra required a much greater volume of excavation than the original plans called for, the technical plant was too light for the task at hand, a bewildering and unmanageable diversity of machinery had been brought in and the employment of over two hundred individual contractors created additional confusion, not to mention skyrocketing costs.

But the most severe and eventually crippling problem was caused by the ravages of yellow fever, typhoid fever and malaria. Enormous sums were spent on hospital facilities which were praised as the finest of their time but provided little relief since the causes of the diseases and effective cures remained elusive. As a result, about 22,000 workers died on the job, making it increasingly difficult to recruit volunteers for canal construction. It must be emphasized, though, that contemporary observers were unanimous in their admiration for those Frenchmen who did go to Panama and stuck to their deadly jobs with a courage comparable to that of soldiers in battle.

Combined into one confusing knot, the medical, technical and financial problems became insurmountable for Lesseps, whose Compagnie Universelle du Canal Interocéanique declared bankruptcy in 1889. One and a half billion francs had been expended and 70 million cubic yards had been excavated, but in the end 800,000 shareholders, mostly from the low- and middle-income range, lost every franc of their investment. It was the biggest financial fiasco of the nineteenth century. Revelations about the astronomical bribes and kickbacks involved added a great deal of legitimate bitterness to the ensuing public debate.

In 1894, a new French canal company was founded with a very modest capital stock of 65 million francs. The company resumed construction on a small scale, primarily trying to maintain the building concession that had been granted to Lesseps by the Colombian government, in whose territory the route of the canal was situated. It was obvious, though, that the French were in no position to complete the project. A bigger economic power was needed to launch a fresh attempt where the French had run aground.

The only major question to be resolved was the set of conditions under which the building concession would change hands. In this respect, the American government was in an enviable position. Clearly, the French canal company desired nothing more than to sell its Panamanian assets and to pull out of a hopeless situation. By the same token, it appeared likely that the Colombian government would be accommodating because a very real possibility existed that the Americans would choose an alternative canal site in Nicaragua. In fact, the feasibility of a Nicaraguan waterway had been studied in detail and an American stock company had made an abortive attempt to begin construction there, losing $6 million in the process. More than that, in January 1902, the House of Representatives had authorized President Theodore Roosevelt to build a Nicaraguan canal at a cost of $180 million, of which $10 million were available for immediate expenditure. Later that year, both houses passed a bill appropriating $135 million for the acquisi-

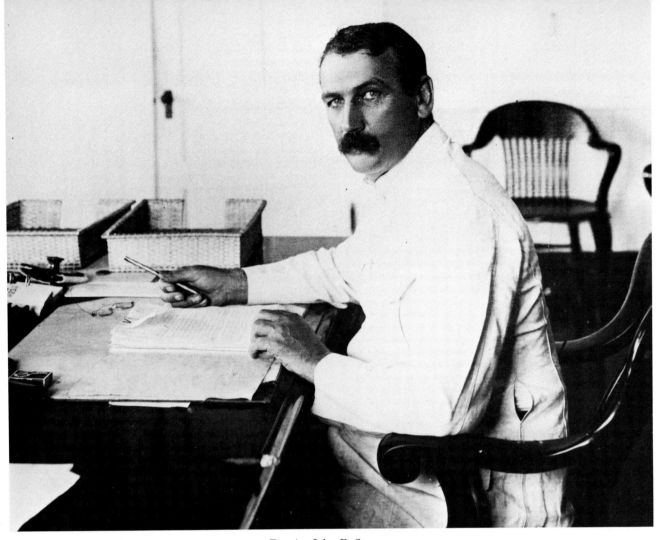

Fig. A. John F. Stevens.

tion and continuation of the Panamanian canal project, but Roosevelt was free to revert to the alternative site should he be unable to obtain favorable conditions from the French and Colombians.

In the following months, a quick agreement was reached with the French canal company, but Colombia was dissatisfied with the less-than-generous American proposal, which offered a down payment of $10 million combined with an annual "rental fee" of $250,000 for a six-mile-wide strip of land across the Isthmus. After unsuccessful Colombian attempts to raise the price of the concession, the American offer was turned down in August 1903.

One might expect that this was a good reason for the Roosevelt administration to revive the Nicaraguan option, but the man who loved to speak softly while carrying a big stick saw still another possibility. There were a number of politicians and businessmen in the city of Panama who could only gain by setting up an independent Panamanian state and who were indeed willing to stage a "revolution"—provided the Americans offered tacit support. Roosevelt made sure of one. Several American ships were stationed near the Isthmus "in the event of any disorder there," troops were landed to "protect life and property,"[3] and the officials of the American-controlled Isthmian Railroad received instructions on whom to transport and whom not to trans-

port. Due to these inconspicuous arrangements, the Republic of Panama successfully seceded from Colombia on November 4, 1903. Of course, Roosevelt never admitted that it had been a phony revolution, but 18 years later Colombia received an indemnity of $25 million from the Harding administration, a conciliatory gesture implying that the events of 1903 had taken a somewhat improper course.

Naturally, the new government of Panama was an even weaker negotiating partner than Colombia. Only two weeks after the "revolution" a treaty was signed which granted the United States greater advantages for the same price than had been provided in the earlier, rejected document. Among other things, the width of the canal corridor was increased from six to ten miles and the American authority in this area was upgraded to de facto sovereignty.

With all political problems cleared one way or another, the second, American canal adventure was ready to be launched. An Isthmian Canal Commission assumed authority over Canal Zone affairs and Chief Engineer J. F. Wallace was put in charge of construction. On May 4, 1904, the French property on the Isthmus was formally transferred to the Americans and by September of the same year a labor force of 1800 men had gone to work on the canal. Everything seemed to be on the right track; Roosevelt expected to see "the dirt fly,"

but he was disappointed. Predictably, difficulties arose in the command structure because the Isthmian Canal Commission in Washington was unfamiliar with the practical exigencies of Panama. Moreover, the man on the spot, Chief Engineer Wallace, was an indecisive man who never found an effective approach to the many challenges of his job. To make things worse, the health issue became virulent again as yellow fever and malaria cases increased considerably in the spring of 1905. Dr. Gorgas, the chief sanitary officer, quickly countered this danger by an energetic campaign against Aedes and Anopheles mosquitoes which had been identified as carriers of the diseases. As a result, yellow fever was completely wiped out and malaria greatly reduced, but the short flurry of fatal infections had been very detrimental to the workers' morale. Poorly led and beset by medical problems, the American canal offensive began to sputter and stall before it had been fully launched.

President Roosevelt acted swiftly. Dr. Gorgas received all the money he needed for his mosquito warfare, and in July 1905 Wallace was replaced as Chief Engineer by John F. Stevens, whose authority was strengthened at the expense of the unproductive Isthmian Canal Commission. Immediately things began to fall into place. Stevens (Fig. A) was a tough, blunt pioneer type with a reputation for "always being in the right place at the right time and doing the right thing without asking questions about it."[4] He greatly improved the command structure and the general performance of the canal army by establishing what he called "the only policy that leads to efficient administration: to give the official ample authority and hold him strictly responsible for results. Such a policy encourages initiative, which is a most valuable asset to an engineer."[5]

Stevens not only knew how to handle the labor force, he also had no doubt where to concentrate it. In the 1890s, he had built the Great Northern Railroad across the Rocky Mountains. This railroad experience proved to be an ideal prerequisite for the excavation of the Panama Canal which, after all, "was simply a problem of transportation," as Stevens concluded correctly. In keeping with this conclusion he made every effort to "devise such a system of trackage, as would permit the maximum number of immense steam-shovels to be operated with the least possible interference with each other."[6] Apart from that, Stevens built up a machine park, a supply system and housing facilities for a labor force which was eventually to reach a size of over 60,000 people (families included). Put differently: in contrast to Wallace, Stevens understood very well that a complex infrastructure had to be established before excavation and construction work could begin in earnest. Consequently he concentrated all his resources on these preparatory activities, postponing the deployment of a full-fledged construction army and the "flying of the dirt" to a later stage.

After a year and a half, the necessary groundwork was completed, the long-delayed decision in favor of a lock canal (rather than a sea-level passage) had been taken and a transition to actual construction work could be made—just in time for a grand event that emphasized the high rank given to the canal enterprise among national priorities: President Roosevelt paid a three-day visit to the Canal Zone, bringing with him a large contingent of newspaper men eager to report on the first foreign trip ever made by a President of the United States while in office. There was no real necessity for this spectacular excursion, but, apart from satisfying Roosevelt's great natural curiosity, it enhanced the general popularity of the Panamanian venture, facilitated future appropriations in Congress and also raised the morale of the labor force to a new high. How much, indeed, the President was striving for this latter effect can be gathered from a kind of pep talk he delivered to American engineers at Colon on November 17, 1906:

> As I have seen you at work, seen what you have done and are doing, noted the spirit with which you are approaching the task yet to be done, I have felt just exactly as I should feel if I saw the picked men of my country engaged in some great war. I am weighing my words when I say that you here who do your work well in bringing to completion this great enterprise will stand exactly as the soldiers of a few, and only a few, of the most famous armies of all the nations stand in history. This is one of the great works of the world; it is a greater work than you yourselves at the moment realize. . . . I go back a better American, a prouder American, because of what I have seen the pick of American manhood doing here on the Isthmus.[7]

It was a speech likely to please the men on the job and to cheer them on to even harder work. Chief Engineer Stevens, however, was too much of a pragmatist and rugged individualist to be impressed by Roosevelt's patriotic equation of labor force with army. On the contrary, such rhetoric seems to have contributed to his sudden decision to relinquish his position. As he bluntly stated in his letter of resignation to the President: "The 'honor' which is continually being held up as an incentive for being connected with this work, appeals to me but slightly. To me the canal is only a big ditch, and its great utility when completed, has never been so apparent to me, as it seems to be to others."[8]

Roosevelt, of course, was furious, ascribed Stevens' lack of job commitment to "insomnia" and "tropical surroundings"[9] and had a successor appointed within days. This time it was a man who would follow orders—Col. George W. Goethals of the U. S. Army. Goethals added a political dimension to the office of Chief Engineer that had previously been absent. He presided over military exercises on the Isthmus, he delivered patriotic speeches, he entertained congressmen on Panamanian inspection trips, he lobbied in Washington and he even wrote a book in support of his legislative proposals.[10] Basically, he conceived of the Panama Canal as a military installation, urged the construction of strong fortifications and wanted to station an army of 25,000 men on the Isthmus, but most of these ideas found few supporters in Congress.

While Col. Goethals' reign was more glamorous than Stevens', it was no less efficient and productive. Adopting a form of government then appropriately labeled as "benevolent despotism,"[11] he made sure that everybody lived comfortably within a strictly enforced hierarchy of salaries and fringe benefits that left no room for trade unions, and reduced non-Americans and non-

whites to second- and third-class employees. At the same time, Goethals was an adherent of "scientific management" and minute cost-keeping—absolute necessities in a publicly financed enterprise where every cent had to be accounted for at the end of the year.

The undertaking probably most typical of Goethals' leadership was the creation of a weekly newspaper, the *Canal Record*, in which every expenditure and all work progress were faithfully documented. The publication of these regular reports was doubly useful. While they fostered a spirit of competition in the work force (every steam-shovel crew wanted to post the biggest weekly output), they also kept the American public informed about and supportive of the canal project, which by and by turned out to be much more expensive than had been anticipated in 1903. The higher costs were caused in part by the installation of the locks with their massive concrete walls, sophisticated steel machinery and elaborate safety measures which nobody had foreseen at the outset. Equally unexpected was the fact that the piercing of the mountain range at Culebra was greatly complicated by huge slides which added considerably to the total volume of excavation. The problem grew so severe that at times the successful completion of the canal seemed to be in jeopardy, but patient digging prevailed eventually, the width of the canal trench being tripled in the process.

Clearly, the canal battle was to be won or lost at Culebra. As the most critical and also the most impressive construction feature, the Cut attracted visitors by the thousands. One of them described the extraordinary sight in vivid terms:

> He who did not see the Culebra Cut during the mighty work of excavation missed one of the great spectacles of all ages . . . From its crest on a working day you looked down upon a mighty rift in the earth's crust, at the base of which pigmy engines and ant-like forms were rushing to and fro without seeming plan or reason. Through the murky atmosphere strange sounds rose up and smote the ear of the onlooker with resounding clamor. He heard the strident clink, clink of the drills eating their way into the rock; the shrill whistles of the locomotives giving warning of some small blast, for the great charges were set off out of working hours when the Cut was empty; the constant and uninterrupted rumble that told of the dirt trains ever plying over the crowded tracks; the heavy crash that accompanied the dumping of a six-ton boulder onto a flat car; the clanking of chains and the creaking of machinery as the arms of the steam shovels swung around looking for another load; the cries of men, and the booming of blasts. Collectively the sounds were harsh, deafening, brutal such as we might fancy would arise from hell were the lid of that place of fire and torment to be lifted.
>
> But individually each sound betokened useful work and service in the cause of man and progress. . . .[12]

In the fall of 1913 all machinery was removed from Culebra Cut and its bottom was filled with water. The "first man-made canyon"[13] thus lost some of its most spectacular features, but came closer to fulfilling its practical destination. On August 15, 1914, well within the tentative timetable adopted at the outset of construction, the Panama Canal was inaugurated by S.S. *Ancon* which traversed the waterway from one end to the other in 9 hours and 40 minutes. Instead of the $135 million anticipated in 1903, a grand total of $352 million had been expended, but it was a good investment. Up to the present day the Panama Canal has continued to function smoothly without any noteworthy technical modifications.

The construction of the Panama Canal was an industrial venture of such magnitude, and President Roosevelt promoted it in such spectacular ways, that it was bound to attract enormous public attention. Over a span of ten years, beginning in 1904, countless books and newspaper and magazine articles were published on Panamanian subjects, many of them richly illustrated with photographic reproductions. In fact, along with the Spanish-American War and the San Francisco earthquake, the canal enterprise was one of the first major news stories to benefit fully from the perfection of photomechanical printing processes at the end of the nineteenth century. Before that time, photography had been a less than ideal recording medium because it had to be laboriously "translated" into line drawing to be put in mass circulation. Only in the 1890s had efficient gravure and halftone techniques become available which permitted the direct, quick and cheap reproduction of photographs in large book, newspaper and stereograph editions.[14] Commercial photography in general and photojournalism in particular were greatly boosted by this "halftone revolution." Assured of a new mass market for their pictures, various firms and individuals (Underwood & Underwood, Keystone, Brown Brothers, H. C. White and others) began to cover noteworthy events in a big way. Naturally the great news value of the Panama Canal was not lost on these photographers; taking regular trips to the Isthmus, they gradually compiled an awesome body of visual information that can still be studied in such magazines as *Harper's Weekly* or *Scientific American*, in stereographic sequences and in picture books.[15]

The present volume, however, is largely based on a different and rather special picture source: a negative archive of over 10,000 images amassed by Ernest Hallen, the Official Photographer of the Isthmian Canal Commission. Systematically covering every aspect of the construction activities and carrying meticulous captions, these images provide the best available basis for a photographic history of the construction of the Panama Canal. The well-preserved original negatives also guarantee excellent picture quality.

The presence of an Official Photographer on the Isthmus is probably less unusual than it may seem to the modern reader. As the exact opposite of "high-art" photography, camera coverage of industrial subjects has received little attention in photohistorical writings;[16] nevertheless, it represents a major and fascinating field of photographic activity throughout the nineteenth century. To avoid misunderstandings it should be stressed that we are not referring here to occasional snapshots of a machine, a factory or a laborer, but to the systematic documentation of a given industrial production process by a specially appointed photographer who remains on the job for months, if not years. Among the earliest examples of such comprehensive construction records are Delamotte's photographs of the Crystal Palace at

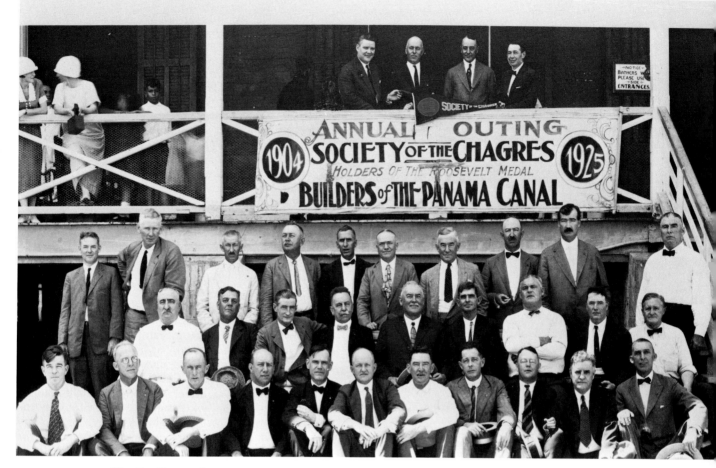

Fig. B. Chagres Society outing of 1925, with Hallen in the front row, fifth from the right.

Sydenham (1854–55), Howlett's *Great Eastern* sequence (1855–57) and Delmaet's and Durandelle's series of the Paris Opéra (ca. 1864–74).[17] While such documentary projects were mostly commissioned by private construction firms, government agencies were also very keen to obtain photographic records of major public works such as railroad lines and administration buildings. Numerous sequences of this kind were executed under Napoleon III. In American government departments, the employment of staff photographers became a fairly regular practice around 1900. From 1903 the Bureau of Reclamation even used a whole team of cameramen to document the progress of countless irrigation projects in the western part of the country.[18]

Thus it was only logical that an Official Photographer was attached to the large American work force in Panama, especially since the usefulness of pictorial canal records had already been proven by Lesseps, whose *Bulletin du Canal Interocéanique* had been enhanced by numerous photographic illustrations. In fact, a good batch of these pictures (some of which carry the inscription "A. Blanc phot." and appear on the first pages of our selection) formed the nucleus of the photo archive later built up by Hallen, the American government photographer.[19]

The history of this archive remains somewhat

clouded. On December 9, 1908, the *Canal Record* published a lengthy but vague article from which we can gather that a "picture history" of canal construction, consisting of "official photographs," was in the making.[20] The *Canal Record* also printed several circulars regulating the sale of the pictures. Apparently employees could buy "certain authorized photographs . . . at twenty gold cents each," but only after written application to the "Office Engineer who will authorize or disapprove the issue or sale of such photographs."[21] Unfortunately, the *Canal Record* does not point out when and upon whose initiative this photographic project was started, nor how it was structured. Although the photographer's name is withheld, it can be gathered from different sources.[22] Other pieces of evidence allow us to determine that Hallen arrived on the Isthmus on August 2, 1907, and that he stayed for at least 23 years—well beyond the actual construction period;[23] in the group picture of a Chagres Society outing in 1925 (Fig. B) he appears as the fifth from the right in the front row. In view of this long tenure there can be no doubt that Hallen produced the bulk of the "official" Panama Canal photographs preserved in the National Archives. However, since quite a few pictures can be dated before August 2, 1907,[24] a fairly systematic documentary project seems to have been under way one or two years before Hallen

appeared on the scene. Hallen must have had a predecessor whose identity may always remain a secret, especially since "official" canal photographs were consistently published without credit lines.

Nothing is known about Hallen's career before 1907 or his particular job qualification. Presumably he was a young man with an average photographic training but a more-than-average sense of adventure which prompted him to pursue his calling in the tropics. In looking through the huge archive that constitutes his life's work, it becomes obvious that he acquired adequate technical competence during his 23 years of service in Panama. However, there is no reason to veil the fact that his creative, artistic talents always remained modest. Before taking a picture Hallen saw to it that he had a good vantage point, that the subject was reasonably well lighted and that all important features were included in the frame; beyond that he seems to have had no ambitions. Unfortunately we possess no written information about his technical equipment, but the pictorial evidence points to the stereotyped use of a very limited arsenal. Invariably Hallen employed a view camera for $8'' \times 10''$ glass negatives. His lenses seem to have been of medium range since one never comes across any striking wide-angle or tele-effects. It was a basic, "no frills" photographic outfit, and it was used in a very conservative manner. Practically all of Hallen's pictures are "long shots," to use movie jargon; we hardly ever encounter a close-up or those unusual, surprising angles which were so popular with other industrial photographers, especially during the 1920s (e.g. Sheeler or Renger-Patzsch). Hallen's bland, unimaginative approach is particularly apparent in his group portraits, with their conventional or altogether accidental poses (illustrations 76, 98, 118, 131). In contrast, Hallen's anonymous predecessor seems to have had a considerable talent for the arrangement of delightful group compositions (nos. 77, 78, 97, 100).

No matter how limited Hallen's artistic abilities may have been, his pictures are great and impressive simply because he was fortunate enough to be dealing with a great and impressive subject. And he certainly made every effort to cover this subject as thoroughly as possible. The Canal Zone was dotted with construction sites, and Hallen visited every one of them on a regular schedule, setting up his camera on the same spot over and over again in pursuit of photographic sequences that can be read as visual progress reports. A small selection from a monthly or quarterly picture sequence of this kind is reproduced in nos. 121–124, showing the Miraflores lock site in its natural condition and in various subsequent construction stages.[25]

Apart from actual construction activities, Hallen also systematically documented the administrative structure, the housing and supply facilities and the social aspects of the enterprise. As the *Canal Record* reported in 1908:

> The human side of the great task is revealed in photographs of quarters, hotels, mess houses, clubs, and hospitals, and in pictures of men who do the work. No class is neglected. West Indians, Europeans, and Americans alike, are represented. The interiors and exteriors of the homes they live in, the places where they eat, the buildings assigned for recreation, churches and lodge rooms, baseball grounds—all phases of Canal Zone life have a place in this picture story of the Panama Canal.[26]

Altogether, Hallen amassed a remarkably comprehensive and diversified picture archive that could be used on several different levels. In the offices of the engineers the "official" photographs were carefully studied and filed as scientific documents that demonstrated special construction techniques and regular work progress on the various building sites. Apart from that, there were many thousand Isthmian workers and tourists who liked to buy "authorized" Hallen pictures for their souvenir value. But, most important, the Isthmian Canal Commission generously made its photographic records available to the printed media in the United States. Widely reproduced in government reports, books and magazines, they kept the taxpayer informed about the Panamanian venture and seem to have been quite instrumental in fostering public support despite soaring costs.[27]

While the popularity of Hallen's pictures dates back 70 years, they remain relevant today. The bills have long been paid, but Panama is still on our minds. Seen in historical perspective, many aspects of the great enterprise even begin to reveal a significance altogether hidden to contemporary observers. This is certainly true with respect to the political intricacies of a half-colonial adventure which do not concern us here. It is also true with respect to the bold technological efforts that guaranteed the canal's successful completion. Today we are living in an age of minicomputers and satellites which are inconspicuous in size but possess a capacity almost beyond human comprehension. Around 1900, industrial technology had a different face. It was still in a comparatively primitive stage, and there still was a close relation between the size and the power of a machine. A 95-ton steam shovel *was* huge and heavy and uncouth; its brute force *was* directly expressed in the massive proportions of its steel frame. To modern eyes these gigantic machines grinding through the Cut seem to have a prehistoric, dinosaurlike quality. They take us back to a different era, to what one might call the "heroic" age of industry.

In recent years we have generally become aware that technology has its own history, and even more than human vicissitudes, this history seems to follow highly dynamic, if not explosive patterns. We can daily make the observation that a small span of time may comprise an enormous leap in quality in the evolution of technical products. Put differently: as the pace of technical innovation accelerates, existing machinery becomes obsolescent more rapidly. In view of this it is only logical that the documentation of major historical achievements in the continuous flow of technological progress has become as vital a concern in our days as the search for ancient cities in Schliemann's time. In fact, industrial archaeology is in the course of establishing itself as a full-fledged academic discipline at many universities. It is not the least of Hallen's merits that his picture history of the Panama Canal provides us with a fascinating source for this new form of archaeological inquiry.[28]

Notes

1. This text (and the picture captions) are based on the following historical studies, which also can be recommended for supplementary reading: J. B. Bishop, *The Panama Gateway*, new and revised edition, New York, Charles Scribner, 1915; W. L. Sibert & J. F. Stevens, *The Construction of the Panama Canal*, New York, D. Appleton, 1915; W. J. Abbot, *Panama and the Canal in Picture and Prose*, New York, Syndicate Publishing Co., 1913; I. E. Bennett, *History of the Panama Canal: Its Construction and Builders*, Builder's Edition, Washington, D.C., Historical Publishing Co., 1915; G. Mack, *The Land Divided: A History of the Panama Canal and Other Isthmian Canal Projects*, New York, Alfred Knopf, 1944; J. and M. Biesanz, *The People of Panama*, New York, Columbia University Press, 1955; D. McCullough, *The Path Between the Seas: The Creation of the Panama Canal, 1870–1914*, New York, Simon and Schuster, 1977. The books by Mack and McCullough contain comprehensive bibliographies.
2. Josephus Acosta, *Natural and Moral History of the Indies*, 1625; quoted from Bennett, p. 120.
3. Bishop, pp. 126f.
4. Quoted from McCullough, p. 462.
5. J. F. Stevens, *An Engineer's Recollections*, New York, McGraw-Hill, 1936, p. 44.
6. Sibert & Stevens, pp. 76f.
7. T. Roosevelt, "Special Message of the President of the United States Concerning the Panama Canal, Communicated to the Two Houses of Congress on December 17, 1906," Washington, D.C., 1906, p. 16.
8. Quoted from McCullough, p. 504.
9. *Ibid.*, p. 505.
10. G. W. Goethals, *Government of the Canal Zone*, Princeton, Princeton University Press, 1915.
11. J. B. Bishop, *Goethals, Genius of the Panama Canal: A Biography*, New York, Harper, 1930, pp. 227 and 249.
12. *Abbott*, pp. 210f.
13. Bishop, *Panama Gateway*, p. 195.
14. See H. Gernsheim, *The History of Photography from the Camera Obscura to the Beginning of the Modern Era*, enlarged and revised edition, New York, McGraw-Hill, 1969, pp. 539 ff.; W. C. Darrah, *Stereo Views: A History of Stereographs and Their Collection*, Gettysburg, Pa., Times and News Publishing Co., 1964, pp. 114 and 117.
15. To name only a few picture books: *King's Views of the Panama Canal in the Course of Construction*, New York, Moses King, 1912; *Panama Canal Pictures, Showing the Latest Photographs of the Progress of Construction . . .*, Philadelphia, Wilmer Atkinson, 1913; *Photogravure Reproductions of the Panama Canal*, Passaic, N.J., The Rotary Photogravure Co., 1913; *The Panama Canal During Construction, From Photographs* by Edith H. Tracy, 1913, New York, Redfield Brothers, 1914. Also see Abbott and Bennett.
16. Sporadic references to industrial photography are made by Gern-

sheim throughout his comprehensive history; a good survey of the relevant American material has recently been published by J. Hurley: *Industry and the Photographic Image: 153 Great Prints from 1850 to the Present*, ed. by F. J. Hurley, New York, Dover, 1980.
17. For Delamotte's series *The Progress of the Crystal Palace, Sydenham*, see Gernsheim, p. 280. The unpublished series by Howlett and by Delmaet and Durandelle are preserved at George Eastman House, Rochester, N.Y.
18. The documentary projects carried out by the Bureau of Reclamation and various government agencies under Napoleon III are unpublished, but can be studied at the National Archives, Washington, D.C., and the Bibliothèque Nationale, Paris.
19. This fact and the reference to the *Bulletin du Canal Interocéanique* are given in: *Canal Record* 2, Dec. 1908, p. 115. Several photographs of French construction activities between 1886 and 1904 are preserved at the National Archives, Washington, D.C. Others are reproduced in: Ph. Bunau-Varilla, *Panama: The Creation, Destruction and Resurrection*, London, Constable, 1913. A complete run of Lesseps' *Bulletin* as well as photo albums of canal construction during the 1880s are preserved in the Bibliothèque Nationale, Paris.
20. *Canal Record* 2, Dec. 9, 1908, p. 115.
21. *Canal Record* 1, Feb. 12, 1908, p. 190.
22. We are referring here to two contemporary publications: F. J. Haskins, *The Panama Canal: Illustrated from Photographs Taken By Ernest Hallen, Official Photographer of the Isthmian Canal Commission*, New York, Doubleday, Page and Co., 1913; E. Hallen, *The New Pacific Fleet through the Panama Canal, July 1919*, Newark, N.J., Panama Pictorial Co., 1919.
23. The arrival date given in *Canal Record* 7, April 22, 1914, p. 332. As far as I know, Hallen's last appearance in a group portrait occurred in 1930, but he may have stayed in Panama several years longer.
24. Some are dated 1905 and 1906; others can be attributed to this early period on the basis of the caption style. Still others were published before 1907; see especially Roosevelt's illustrated message to Congress, quoted in note 7, above.
25. Unfortunately Hallen's negative collection at the National Archives does not seem to contain any complete sequence of monthly exposures of a given site. From the negative numbering system it can be concluded that originally these sequences were much more comprehensive. Apparently a good many negatives were "weeded out" some time before the collection was transferred from Panama to Washington, D.C.
26. *Canal Record* 2, Dec. 9, 1908, p. 115.
27. See especially the photographically illustrated *Annual Reports of the Isthmian Canal Commission*, 1904–1914.
28. For an introduction to industrial archeology see: K. Hudson, *Industrial Archaeology: An Introduction*, second revised edition, Cambridge, Cambridge University Press, 1967.

Picture Credits and Sources

Photographers

Anonymous: 1, 3, 4, 28, 59, 61
A. Blanc: 2
W. A. Fishbaugh: 29, 58, 60
Marine: 11
Underwood & Underwood: 32, 33, 86
H. C. White: 34
All other photographs are by Ernest Hallen or his unknown predecessor in the capacity of "Official Photographer of the Isthmian Canal Commission."

Sources

Almost all pictures are reproduced from negatives, prints or lantern slides in the National Archives, Washington, D.C. The only exceptions are:
32, 33, 34: *Harper's Magazine* 50, Dec. 8, 1906
59: W. J. Abbot, *Panama and the Canal in Picture and Prose*, New York, Syndicate Publishing Co., 1913
Introduction Fig C: J. and M. Biesanz, *The People of Panama*, New York, Columbia University Press, 1955

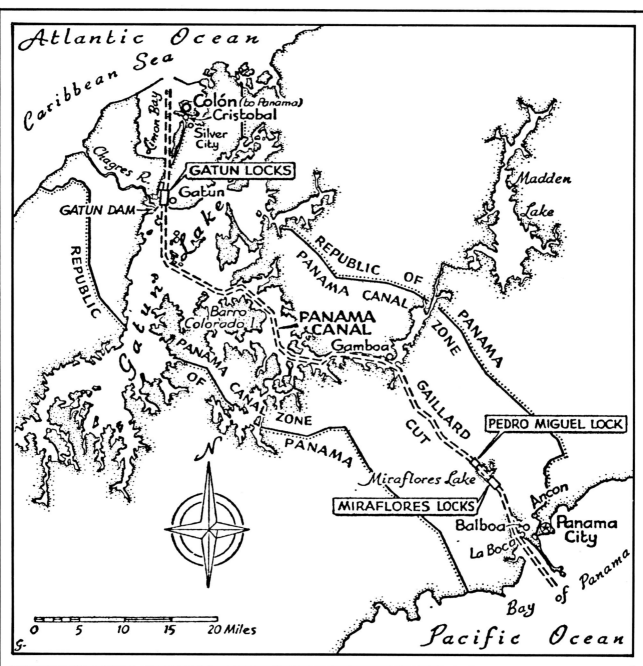

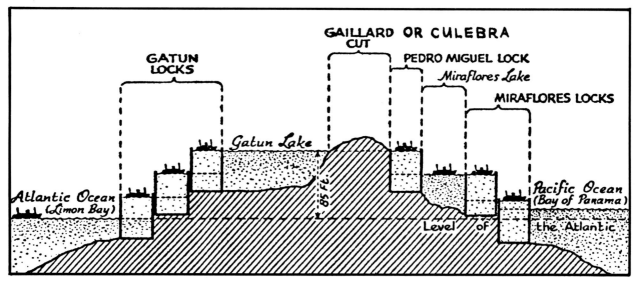

Cristobal to Balboa

A Boat Trip through the Panama Canal

[The following text was written some time before the first ship entered the canal and is therefore half-fictive. However, since it describes not only the future, completed state of the canal, but also various construction phases it provides an ideal introduction to our pictures, which focus on building activities. The text is quoted with abridgments from: Willis J. Abbot, *Panama and the Canal in Picture and Prose*, New York, Syndicate Publishing Co., 1913, pp. 135 ff.]

[If a visitor] desired to see the canal in its completed state—say after 1914—he would take a ship at the great concrete docks at Cristobal [no. 110]. . . . Steaming out into the magnificent Limon Bay, the vessel passes into the channel dredged out some three miles into the turbulent Caribbean, and protected from the harsh northers by the massive Toro Point breakwater. The vessel's prow is turned toward the land, not westward as one would think of a ship bound from the Atlantic to the Pacific, but almost due south. The channel through which she steams is 500 feet wide at the bottom, and 41 feet deep at low tide. It extends seven miles to the first interruption at Gatun, a tide water stream all the way. . . .

At [Gatun] the shores rise higher and one . . . will be able to clearly discern far ahead a long hill sloping gently upward on each side of the canal, and cut at the center with great masses of white masonry, which as the ship comes nearer are seen to be gigantic locks, rising in pairs by three steps to a total height of 85 feet [nos. 62, 68]. . . .

Up to this time the ship had been proceeding under her own steam and at about full speed. Now slowing down she gradually comes to a full stop alongside the central guide wall. Here will be waiting four electric locomotives, two on the central, two on the side wall. Made fast, bow and stern, the satellites start off with the ship in tow [no. 127]. It will take an hour and a half to pass the three locks at Gatun. . . .

[As] the ship steams into the open lock the great gates which are to close behind her and hold the water which flows in from below, slowly lifting her to the lock above, are folded flush with the wall, a recess having been built to receive them. The chamber which the vessel has entered is 1000 feet long, . . . 110 feet wide and will raise the ship 28 $\frac{1}{3}$ feet [nos. 119, 120 for the process at Miraflores]. If the ship is a comparatively small one the full length of the lock will not be used, as intermediate gates are provided which will permit the use of 400 or 600 feet of the locks as required—thus saving water, which means saving power, for the water that raises and lowers the ships also generates electric power. . . .

Back of each pair of gates is a second pair of emergency gates folded back flush with the wall and only to be used in case of injury to the first pair [no. 125 for gates at Miraflores]. On the floor of the canal at the entrance to the lock lies a great chain, attached to machinery which, at the first sign of a ship's becoming unmanageable, will raise it and bar the passage. Nearly all serious accidents which have occurred to locks have been due to vessels of which control has been lost, by some error in telegraphing from the bridge to the engine room. For this reason at Panama vessels once in the locks will be controlled wholly by the four locomotives on the lock walls Finally at the upper entrance to the locks is an emergency dam built on the guide wall [no. 128]. . . . [This dam will be activated] if an accident should happen to the gates of the upper lock. . . . The machinery by which all is operated [no. 66] is concealed in the masonry crypts below, but the traveler may find cheer and certainty of safety in the assurance of the engineer who took me through the cavernous passages— "It's all made fool proof".

Leaving the Gatun locks and going toward the Pacific the ship enters Gatun Lake, a great artificial body of water 85 feet above tide water. This is the ultimate height to which the vessel must climb, and it has reached it in the three steps of the Gatun locks. To descend from Gatun Lake to the Pacific level she drops down one lock at Pedro Miguel, 30 $\frac{1}{3}$ feet; and two locks at Miraflores with a total descent of 54 $\frac{2}{3}$ feet. . . . Gatun Lake constitutes really the major part of the canal, and the channel through it extends in a somewhat tortuous course for about twenty-four miles. So broad is the channel dredged—ranging from 500 to 1000 feet in width and 45 to 85 feet in depth—that vessels will proceed at full speed, a very material advantage, as in ordinary canals half speed or even less is prescribed in order to avoid the erosion of the banks.

The lake . . . will in time become a scenic feature of the trip that cannot fail to delight those who gaze upon it. But for some years to come it will be ghastly, a living realization of some of the pictures emanating from the abnormal brain of Gustave Doré [no. 96]. On either side of the ship gaunt gray trunks of dead trees rise from the placid water, draped in some instances with the Spanish moss familiar to residents of our southern states, though not abundant on the Isthmus. More of the trees are hung with the trailing ropes of vines once bright with green foliage and brilliant flowers, now gray and dead like the parent trunk. Only the orchids and the air plants will continue to give some slight hint of life to the dull gray monotony of death. . . .

The waters of the lake cover 164 square miles and are at points eighty-five feet deep. In the main this vast expanse of water . . . is supplied by the Chagres River, though several smaller streams add to its volume. Before the dam at Gatun was built two or three score yards measured the Chagres at its widest point. Now the waters are backed up into the interior far beyond the borders of the Canal Zone, along the course of every little waterway

Fig. C. Map of the Panama Canal Zone, showing the levels of the canal.

that flowed into the Chagres, and busy launches may ply above the sites of buried Indian towns. . . .

In passing through the lake the canal describes eight angles, and the attentive traveler will find interest in watching the range lights by which the ship is guided when navigating the channel by day or by night—for there need be no cessation of passage because of darkness. These range lights are lighthouses of reënforced concrete so placed in pairs that one towers above the other at a distance back of the lower one of several hundred feet [no. 95]. The pilot keeping these two in line will know he is keeping to the center of his channel until the appearance of two others on either port or starboard bow warns him that the time has come to turn. . . .

[After a while] the high bridge by which the railroad crosses the Chagres at Gamboa, with its seven stone piers will be visible over the starboard side. This point is of some interest as being the spot at which the water was kept out of the long trench at Culebra [by means of an artificial dyke; no. 93].

Now the ship passes into the most spectacular part of the voyage—the Culebra Cut [nos. 22–24, 146–149]. During the process of construction this stretch of the work vied with the great dam at Gatun for the distinction of being the most interesting and picturesque part of the work. Something of the spectacular effect then present will be lost when the ships begin to pass. The sense of the magnitude of the work will not so greatly impress the traveler standing on the deck of a ship, floating on the surface of the canal which is here 45 feet deep, as it would were he standing at the bottom of the cut. He will lose about 75 feet of the actual height, as commanded by the earlier traveler who looked up at the towering height of Contractors Hill from the very floor of the colossal excavation. He will lose, too, much of the almost barbaric coloring of the newly opened cut where bright red vied with chrome yellow in startling the eye, and almost every shade of the chromatic scale had its representative in the freshly uncovered strata of earth.

The tropical foliage grows swiftly, and long before the new waterway will have become an accustomed path to the ships of all nations the sloping banks will be thickly covered with vegetation. It is indeed the purpose of the Commission to encourage the growth of such vegetation by planting, in the belief that the roots will tie the soil together and lessen the danger of slides and washouts. . . .

At Pedro Miguel a single lock lets the ship down to another little lake hardly two miles across to Miraflores where two more locks drop it down to tide water [nos. 113–118]. From Miraflores the traveler can see the great bulk of Ancon Hill looming up seven miles away, denoting the proximity of the city of Panama which lies huddled under its Pacific front. Practically one great rock is Ancon Hill. . . . At its base is the new port of Balboa which is destined to be in time a great distributing point for the Pacific coast of both North and South America. For the vessels coming through the canal from the Atlantic must, from Balboa, turn north or south or proceed direct across the Pacific. . . . Fleets of smaller coastwise vessels will gather here to take cargoes for the ports of Central America, or for Ecuador, Colombia, Peru and other Pacific states of South America. The Canal Commission is building great docks for the accommodation of both through and local shipping; storage docks and pockets for coal and tanks for oil. The coaling plant will have a capacity of about 100,000 tons, of which about one-half will be submerged. One dry dock will take a ship 1000 feet long and 105 feet wide . . . [no. 158]. One pier, of the most modern design, equipped with unloading cranes and 2200 feet long is already complete . . . [no. 108]. . . .

The machine shops long in Gorgona and Matachin have been removed to Balboa [no. 109], and though since the completion of the canal the number of their employes has been greatly decreased, the work of repairing and outfitting vessels may be expected to maintain a large population of mechanics. The administration offices now at Culebra will also be moved to Balboa, which in fact is likely to become the chief town of the Canal Zone. . . .

Looking out to sea from the prow of a ship entering the Pacific Ocean you will notice three conical islands rising abruptly from the waves, to a height of three or four hundred feet. To be more precise the one nearest the shore ceased to be an island when the busy dirt trains of the Canal Commission dumped into the sea some millions of cubic yards of material taken from Culebra Cut, forming at once a great area of artificial land which may in ensuing centuries have its value, and a breakwater which intercepts a local current that for a time gave the canal builders much trouble by filling the canal with silt [nos. 26, 27]. The three islands, Naos, Flamenco, and Perico are utilized by the United States as sites for powerful forts. The policy of the War Department necessarily prevents any description here of the forts planned or their armament. . . .

It may be said, however, . . . that by the fortifications on the islands, and on the hills adjacent to the canal entrance, as well as by a permanent system of submarine mines the Pacific entrance to the canal is made as nearly impregnable as the art of war permits. . . .

At Balboa the trip through the completed canal will be ended. It has covered a fraction over fifty miles, and has consumed, according to the speed of the ship and the "smartness" of her handling in locks, from seven to ten hours. He who was fortunate enough to make that voyage may well reflect on the weeks of time and the thousands of tons of coal necessary to carry his vessel from [Cristobal] to Balboa had the canal not existed.

ULRICH KELLER

THE BUILDING
OF THE
PANAMA CANAL
in Historic Photographs

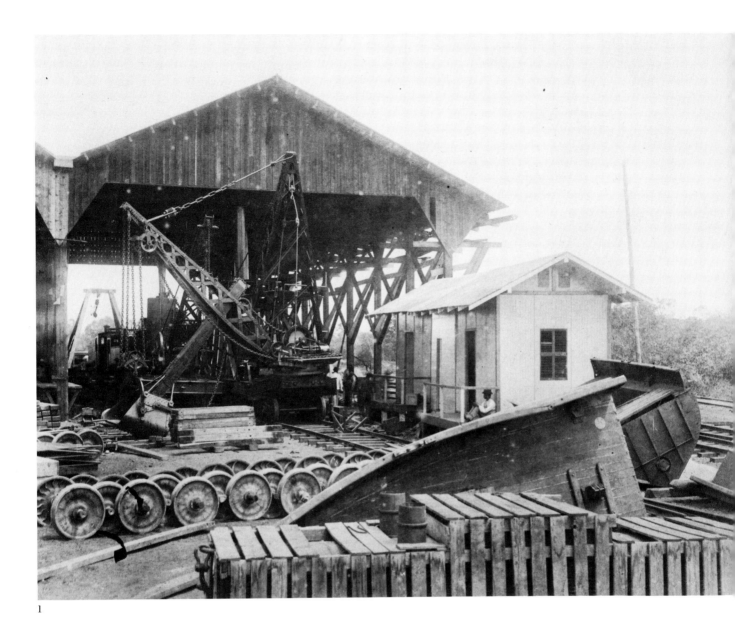

1

The French Fiasco (nos. 1–4). Ferdinand de Lesseps, celebrated builder of the Suez Canal, tackled the project of a canal in Panama in 1879. A colossal stock company was formed, many shiploads of men and machinery went to Panama, an awesome amount of excavation was accomplished, but in eight years the whole undertaking ended in the biggest financial fiasco of the century. Apparently, there were four principal reasons for Lesseps' failure: malaria and yellow fever exacted a terrible death toll of over 22,000 men; the French machinery was too light and lacking in standardization; the use of 200 poorly coordinated contracting firms resulted in high expenses and low efficiency; and the plan for a sea-level canal was unrealistic to begin with.

1. Assembly of Osgood steam shovel at Colon, ca. 1886–88. The French relied on American-made steam shovels that had a modest dipper capacity of two cubic yards and could be used only on soft earth, rather than rock.

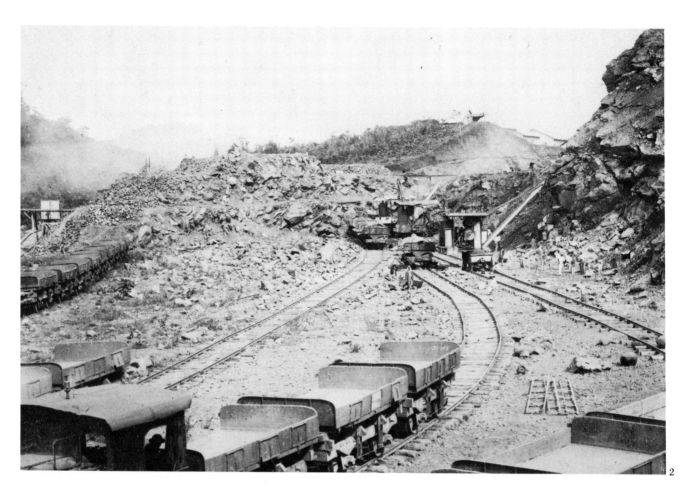

2

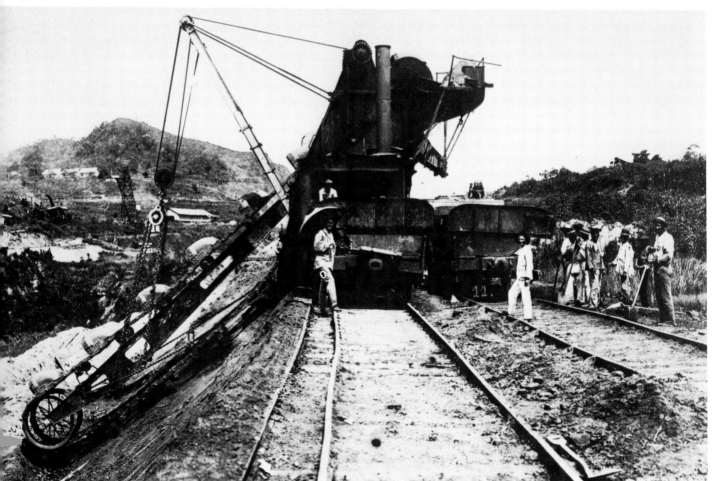

3

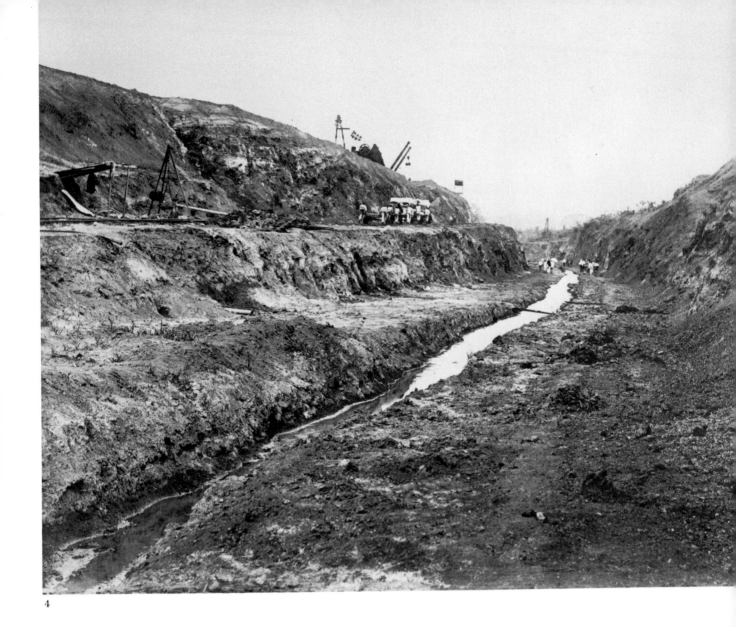

4

2. The hilltop at Bas Obispo torn up by dynamite, August 1886. The French dump cars had a capacity of five to eight cubic yards. In the rainy season they often had to be unloaded by hand because the dirt stuck to the planks. 3. Excavator at work near Empire, ca. 1886–88. Averaging 400 cubic yards a day, the French chain-bucket excavators were less efficient than the steam shovels, which could handle three to four times more. The chain buckets had a volume of three to six cubic feet and emptied their loads on dump cars placed alongside the excavator. 4. Culebra Cut between Culebra and Empire, 1898. After the liquidation of Lesseps' canal company in 1889, French construction work was continued on a small scale by a new company to retain the Colombian building concession.

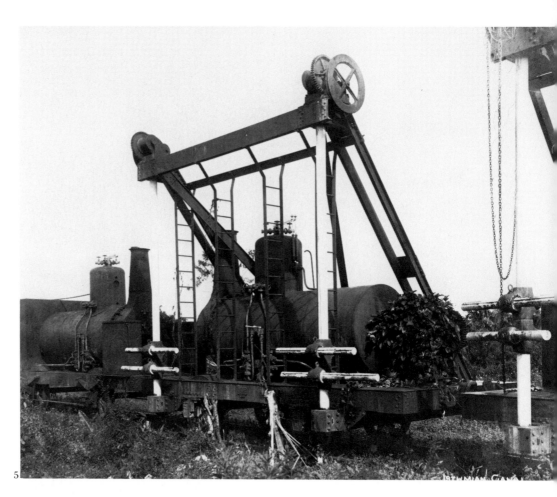

5

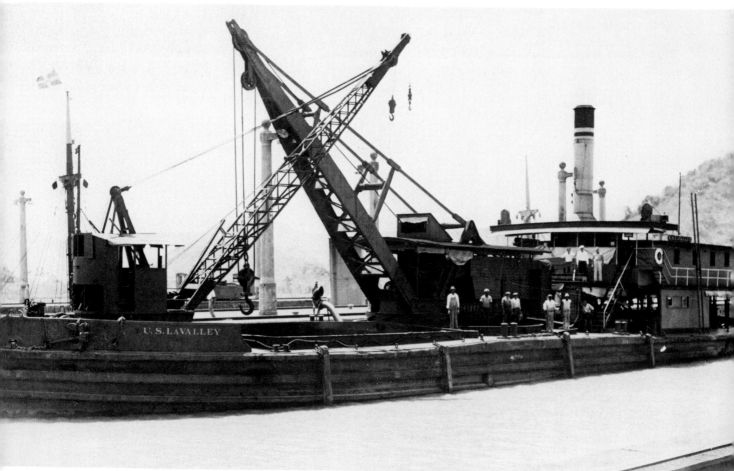

U.S. LAVALLEY

7

8

The French Plant (nos. 5–10). The French brought to the Isthmus the most advanced machinery available at the time. Even though it was too light to accomplish the enormous task at hand, many pieces were of such good quality that the Americans continued to use them.

5. French boiler cars for rock drills at Empire shops, 1905. **6.** Craneboat *La Valley,* built in 1887, last of the French floating equipment, was retired on March 20, 1934. **7.** Rebuilt Belgian locomotive at Empire shops, 1910. **8.** French dump car at Empire shops, 1910. **9.** Old French dump cars at Mount Hope, 1913. The French left behind more than 100,000 tons of scrap material. Most of this chaotic inheritance was gradually brought to the United States by the cement ships *Ancon* and *Cristobal* as ballasting cargo on their return trips.

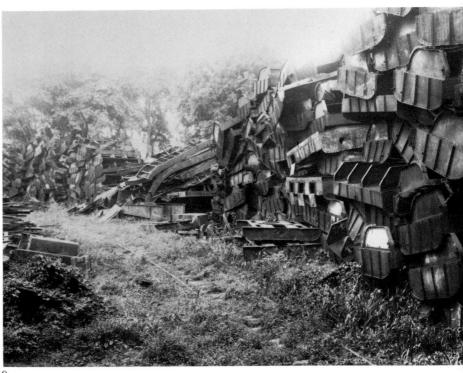

9

10. Old French excavator at Tabernilla, 1913. The huge iron structure pointing to the left is a "transporter," a belt-and-roller mechanism designed to dump spoil at some distance from the canal bed, making railway transportation unnecessary.

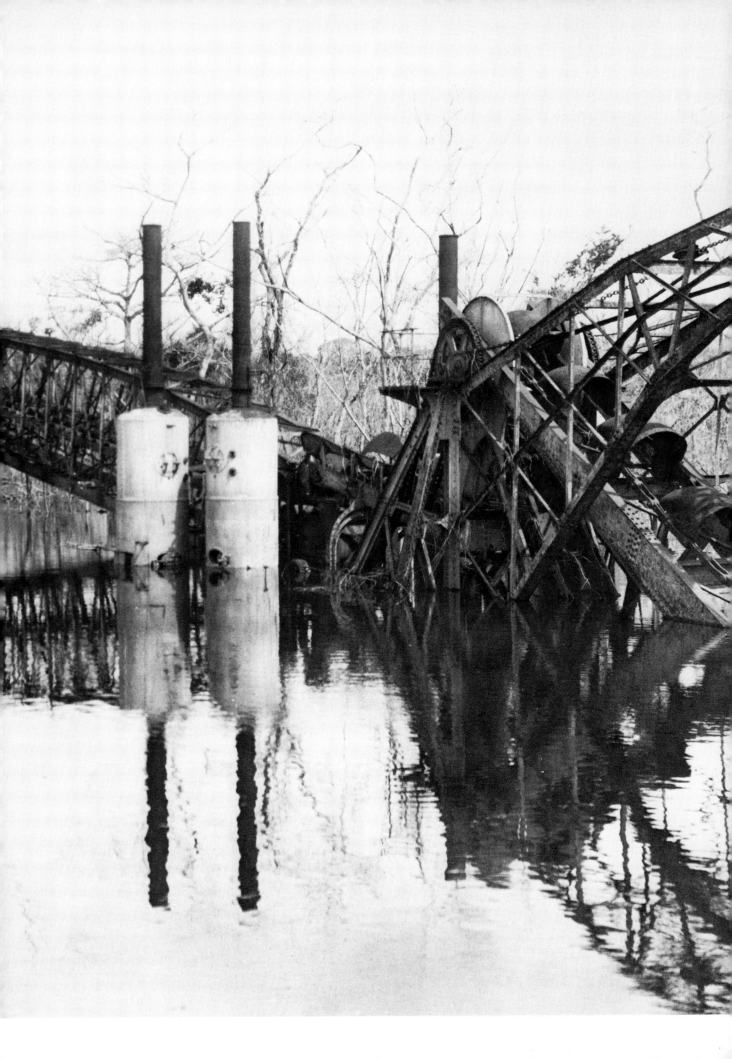

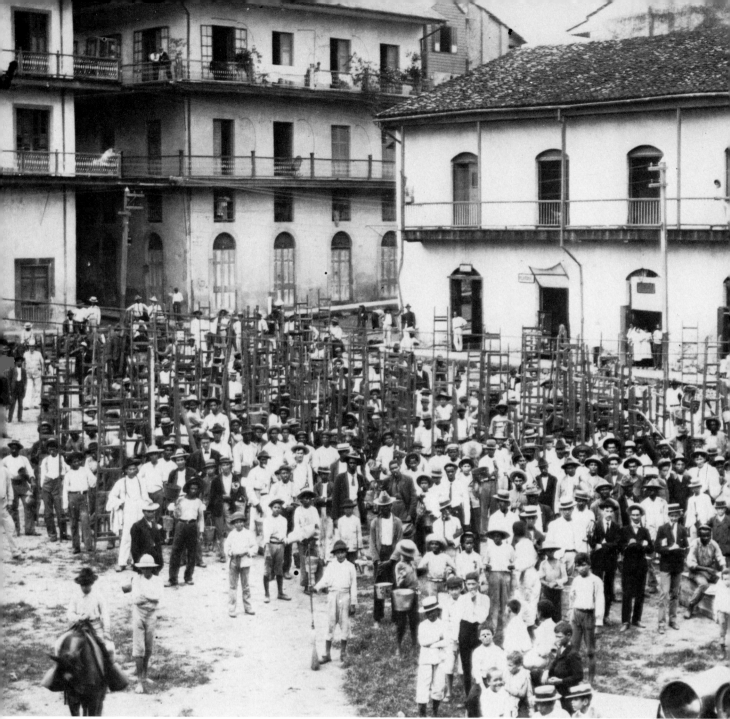

The War Against Yellow Fever (nos. 11–16). When Teddy Roosevelt sent the first Americans to the Isthmus in 1904, their first task was to create healthful living conditions. Luckier than the French, they knew that malaria and yellow fever were transmitted by certain mosquitoes. Consequently the famous Dr. William Crawford Gorgas of the U.S. Army was not content with setting up at Ancon the best tropical hospital of his time; he also orchestrated a relentless, semimilitary campaign against mosquito breeding places. Houses were fumigated and screened, streets paved, swamps dried, rivers sprayed with pesticides. Wherever an Anopheles or Aëdes entered a habitation in spite of such efforts, it was hunted down by trained exterminators. As a result, yellow fever had disappeared from the Isthmus by 1906, while malaria cases were reduced to a tolerable level. The mortality of American employees in Panama was no greater than it would have been in an equally large city at home.

11. The Fumigation Brigade making Panama habitable, 1905. In 1905, yellow fever flared up on the Isthmus, killing several workers and causing hundreds to evacuate to the United States. Dr. Gorgas immediately started a fumigation campaign, and even though this invasion of privacy angered the Panamanians it wiped out the dangerous mosquitoes. **12. Woman's ward, Ancon Hospital.** Ancon Hospital, which could accommodate over 1500 patients, comprised dozens of buildings beautifully located on a hill overlooking the Pacific Ocean. **13. Operating room, Colon Hospital, 1910.**

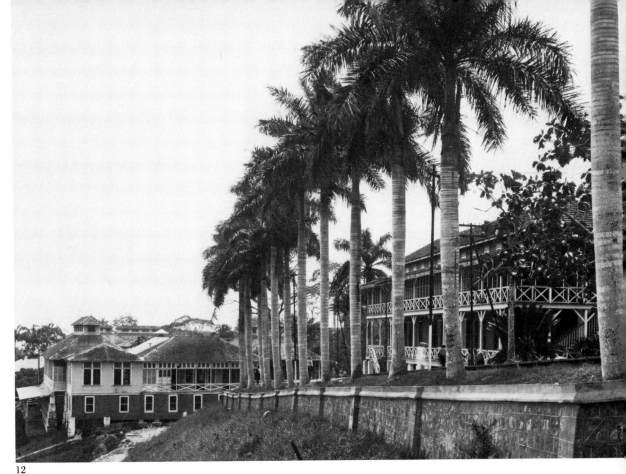

12

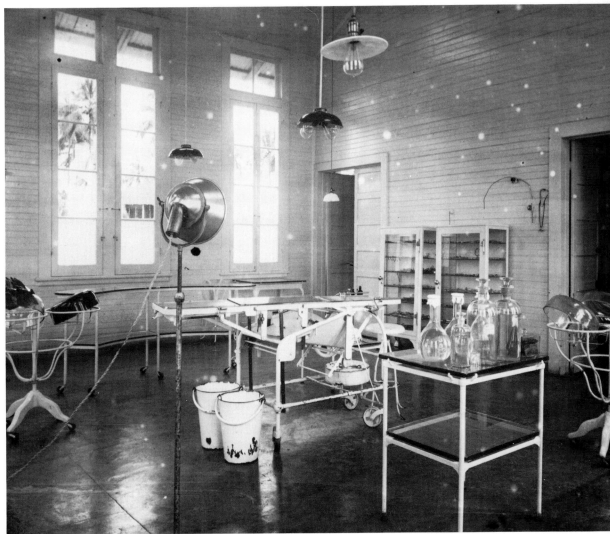

13

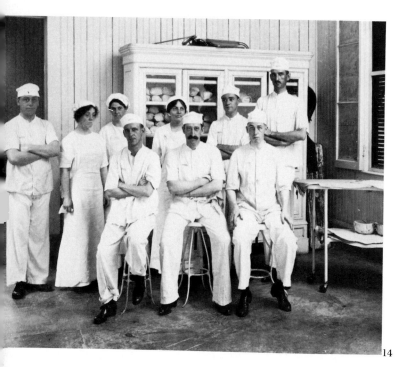

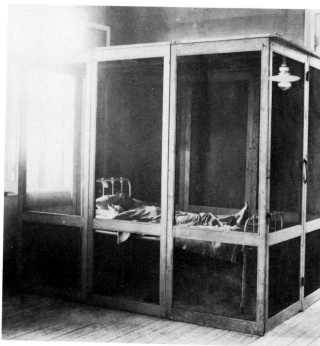

14

15

14. One of Dr. Gorgas' medical teams at Ancon Hospital. **15.** Yellow-fever patient at Ancon Hospital, 1905. The isolation cage prevented mosquitoes from spreading the disease. **16.** Paving Arosamena Street, Panama, ca. 1906. The paving of streets and installation of a sewage system were important steps toward healthful living conditions.

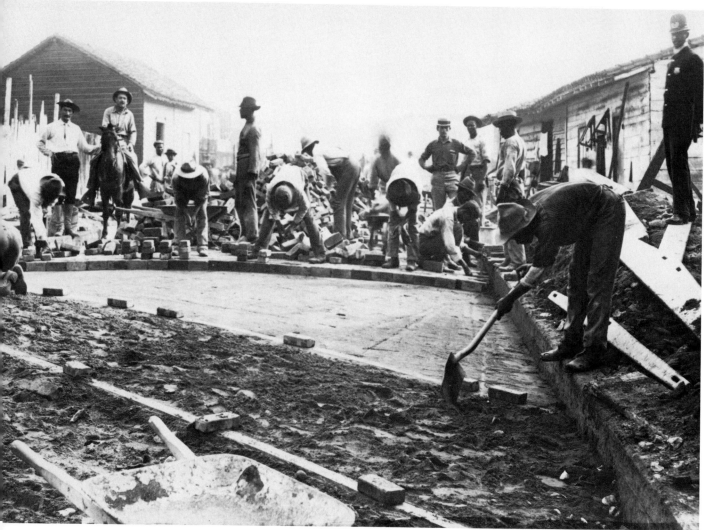

16

17

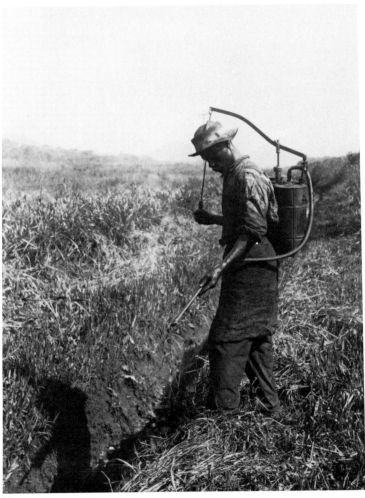

Death to the Mosquito (nos. 17–20). The most effective weapon against the mosquitoes was "larvicide oil," a chemical mixture designed to cover water surfaces with a thin film. Mosquito larvae must periodically come to the water surface to breathe and are killed upon contact with such pesticides.

17. A mosquito-control squad removes containers that offer breeding places to mosquitoes. **18.** A knapsack sprayer works near Miraflores, June 1910.

18

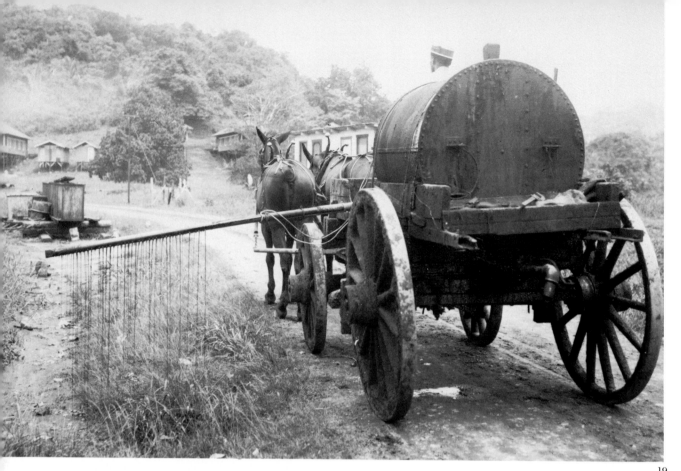

19. Covering a ditch with larvicide oil. **20.** Larvicide plant at Ancon, 1910.

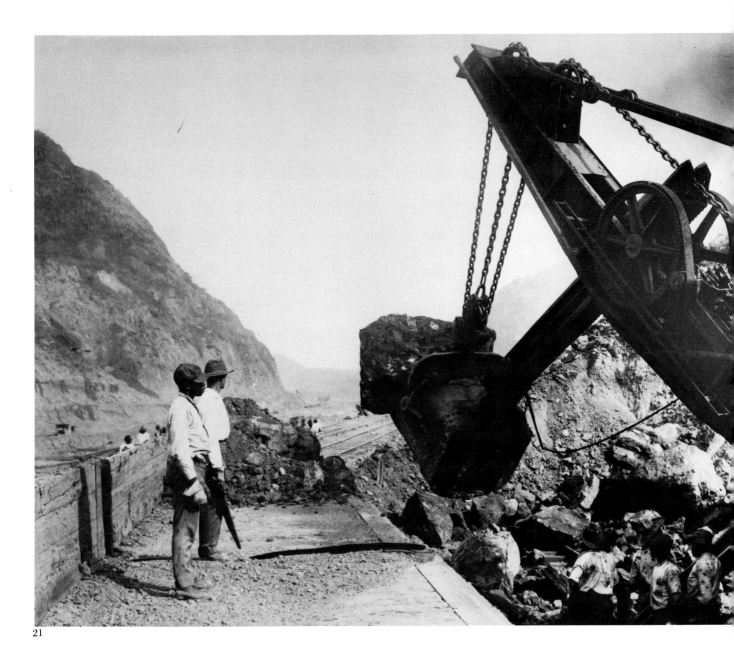

21

The Cut (nos. 21–27). Immediately upon arrival, the Americans went to work near Culebra on a mountain range nine miles wide and 550 feet high which presented the most formidable obstacle to the construction of the canal. The French had excavated 20 million cubic yards here, and before the canal was finished the Americans removed another 105 million at a cost of one dollar per cubic yard. At one point, 9000 workers were employed in this narrow canyon, but final success was largely due to the introduction of superior technical equipment: the American steam shovels could remove five times more material than their French predecessors, and more of

these gigantic machines could be used because the system of removing and dumping the spoil had been perfected. Even the biggest engines were powerless, though, against the rock layers in the Cut that had to be blasted away by dynamite at a rate of six million pounds per year.

21. A steam shovel loads rock in Culebra Cut, March 1911. The dipper of a 95-ton Bucyrus steam shovel, with room for 8.7 tons of rock or 6.7 tons of earth could handle up to 4800 cubic yards of material per eight-hour day.

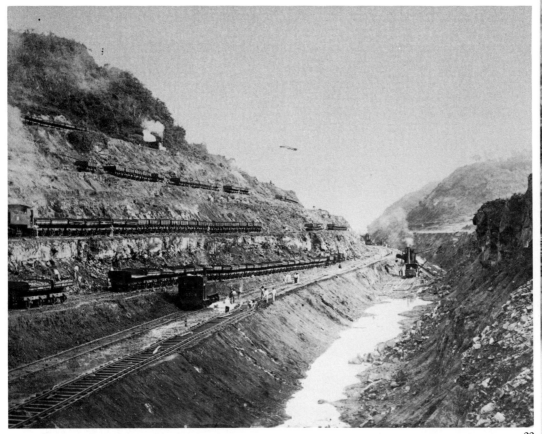

22

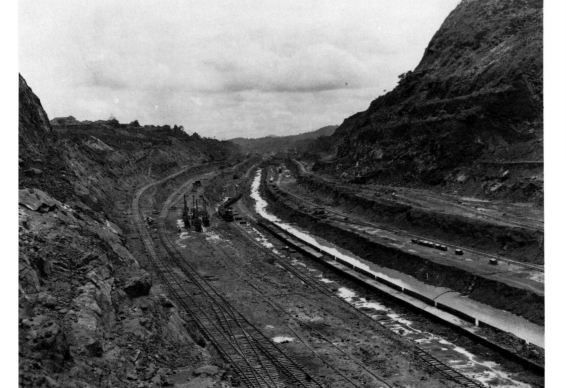

23

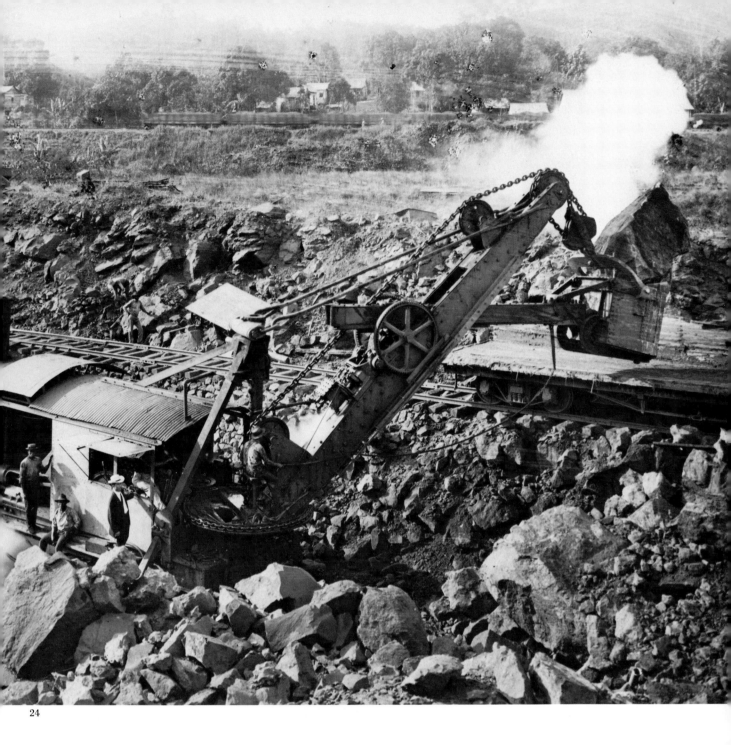

24

22. Excavations at Culebra Cut, looking south, December 1904. Excavations were carried on simultaneously on several levels, and this required a sophisticated railroad network. The picture shows the state of the Cut when it was taken over by the Americans in 1904. 23. Culebra Cut, looking north, June 1910. Six years after the American arrival, the valley between Contractors Hill (left) and Gold Hill (right) had been deepened considerably. Contrary to plans, it also had been necessary to widen it by more than 1000 feet. 24. Steam shovel down to grade at Bas Obispo, March 12, 1909. The operation of a steam shovel required two railroad tracks—one on which it plowed forward, the second alongside it for the dump cars to be loaded. The pile of broken rocks in this picture indicates that a blasting gang had preceded the steam shovel.

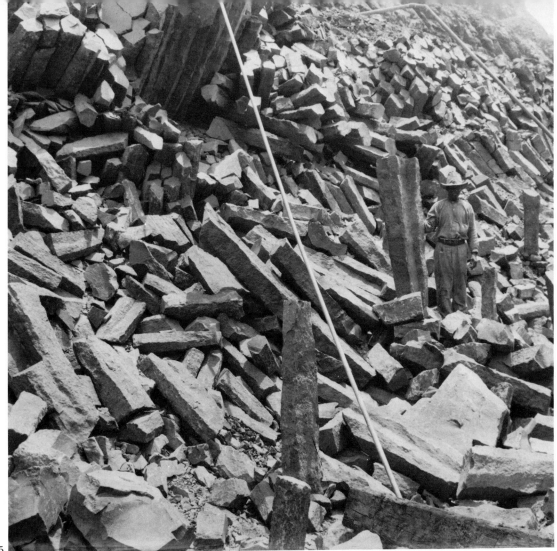

25

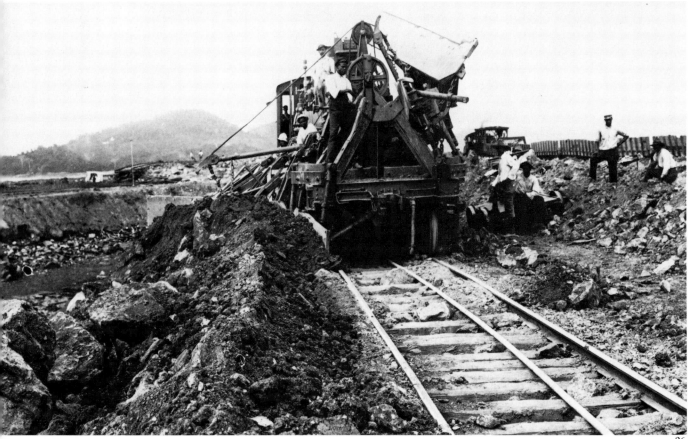

26

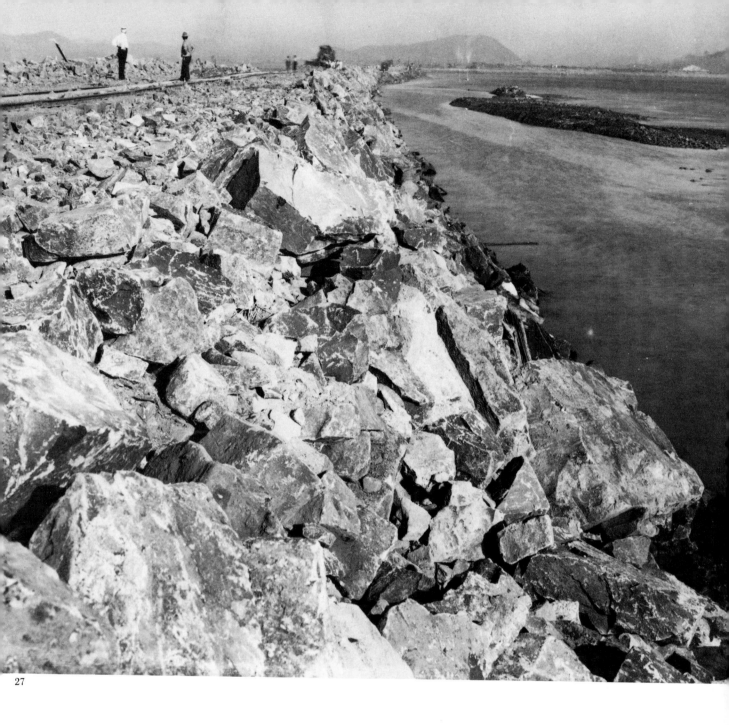

27

25. Culebra Cut, March 1913. The base of Gold Hill shows basaltic columns created by steam shovels. **26. A spreader at work on the Naos Island breakwater, January 11, 1910.** Spreaders were used to shove dumped spoil out of the way. **27. Naos Island breakwater, Bay of Panama, February 1914.** The rock material from Culebra Cut was used in the construction of breakwaters at both ends of the canal.

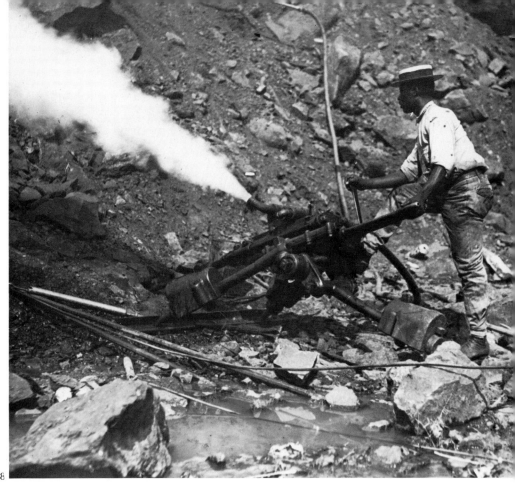

28

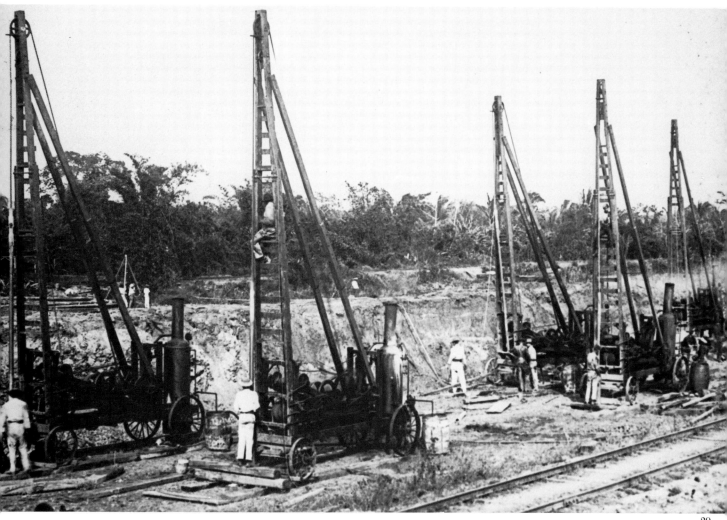

29

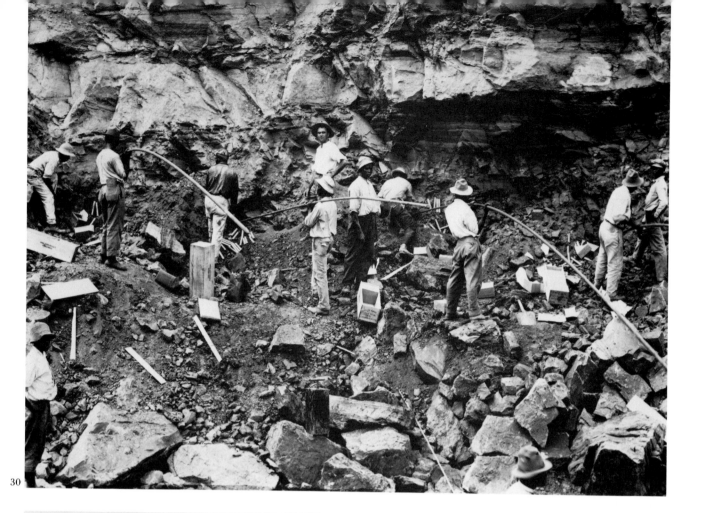

30

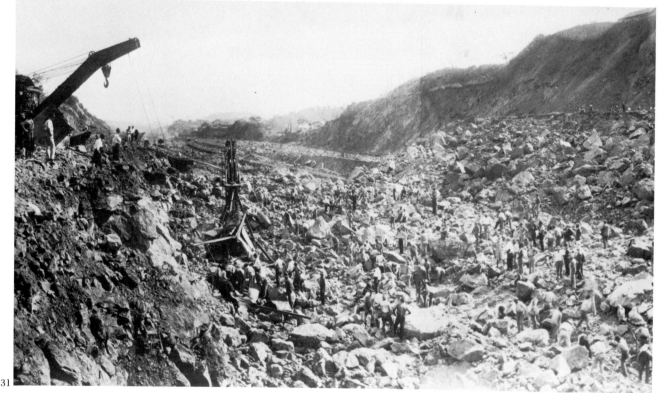

31

Blasting the Way (nos. 28–31). Without dynamite, the rock barrier at Culebra could never have been breached. In 1913, 221 well drills and 156 tripod drills—all driven by compressed air—were at work boring dynamite holes. The average hole was 27 feet deep and up to 90 miles of holes were drilled every month.

28. Man with tripod drill at Culebra Cut. **29.** Battery of well drills at Empire, March 1906. **30.** Loading holes with dynamite to blast a slide in the west bank of Culebra Cut, February 1912. **31.** Culebra Cut at Bas Obispo. This view was taken shortly after the premature explosion of 53 holes containing 44,000 pounds of dynamite on December 12, 1908. 23 workers were killed in the accident.

19

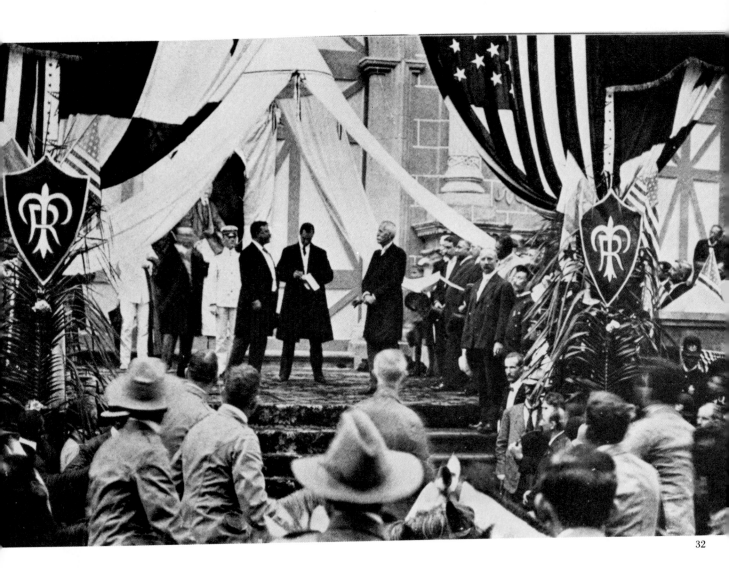

The Supreme Commander (nos. 32–35). President Roosevelt was the moving force behind the construction of the Panama Canal. In November 1906, he even made a three-day visit to the Canal Zone which caused a veritable sensation because no president before him had ever left the country while in office. In Culebra Cut Roosevelt was greeted by the flattering sign: "We'll help you dig it!"

32. President Roosevelt addressing President Amador of Panama on the steps of the Cathedral, Panama, November 15, 1906. **33.** An example of President Roosevelt's method of getting in touch with the work.

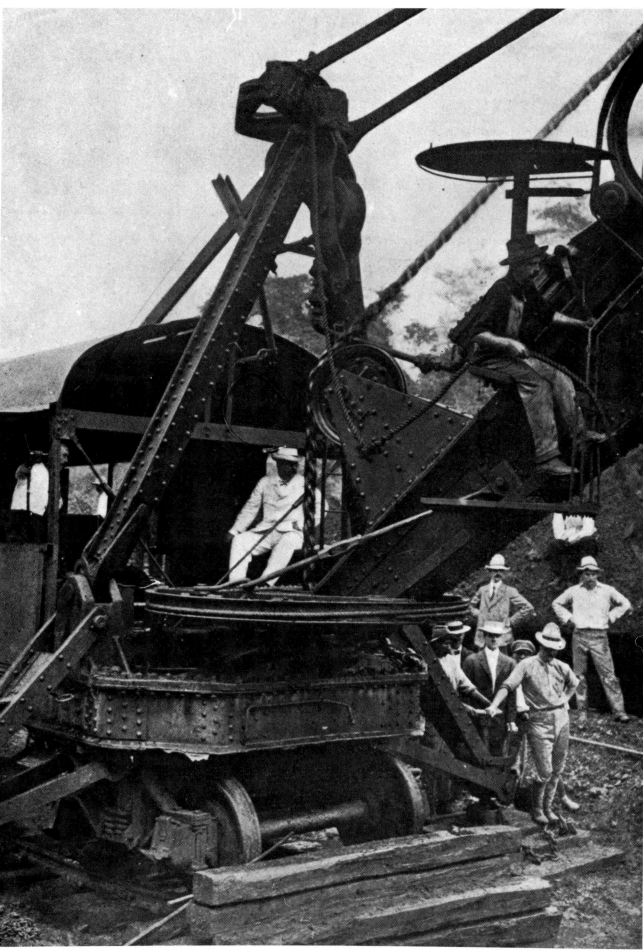

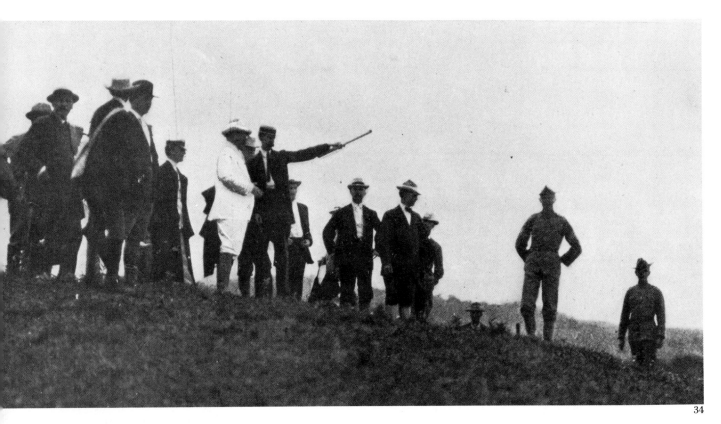

34. President Roosevelt with Engineer Maltby on Gatun Hill, overlooking the valley of the Chagres. **35.** The President sets out for Mount Hope Reservoir with Mrs. Roosevelt and Chief Engineer Stevens.

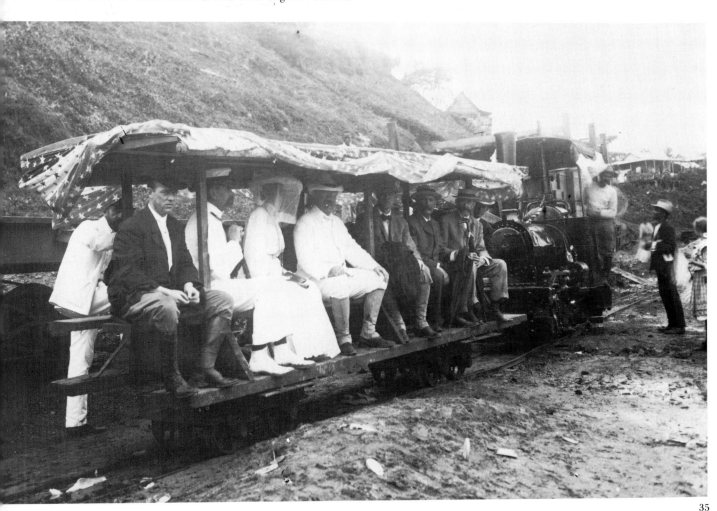

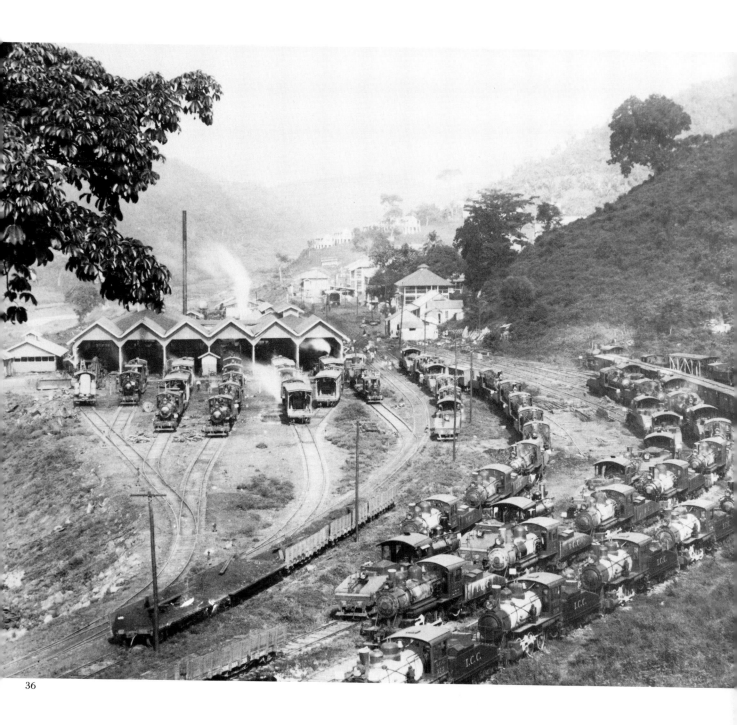

Infrastructure: Railroads (nos. 36–41). Before excavation in the Cut and elsewhere could begin in earnest, the necessary infrastructure had to be provided. Only 47 miles wide, the Isthmus of Panama was fitted out with a complex railroad network covering 450 miles. Basically, the network was the creation of Chief Engineer Stevens, who realized that the problem of the Panama Canal was as much a problem of transportation as excavation. Under the French, excavation capacity had considerably exceeded dumping capacity. Under Stevens, a balance was achieved, with 30 trains moving in and out of Cule-

bra Cut every hour and with hundreds of tracks being shifted every two to three days. The railroad system was the backbone of all canal operations. Apart from a few fire engines there were hardly any automobiles. Cranes, steam shovels, dirt, concrete, food, money, workers, tourists—everything moved on rails in the Canal Zone.

36. General view of railroad shops at Paraiso. The picture gives an idea of the size of railroad operations. In 1913–14 over 4500 men were employed by the Panama Railroad, which was first established by a group of American entrepreneurs in 1855.

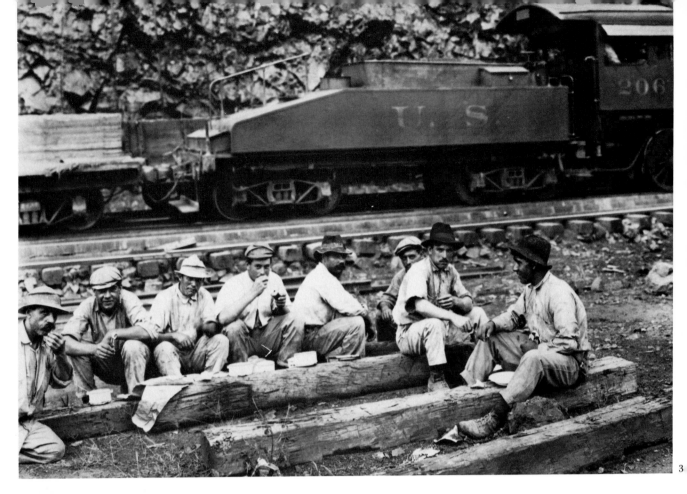

3

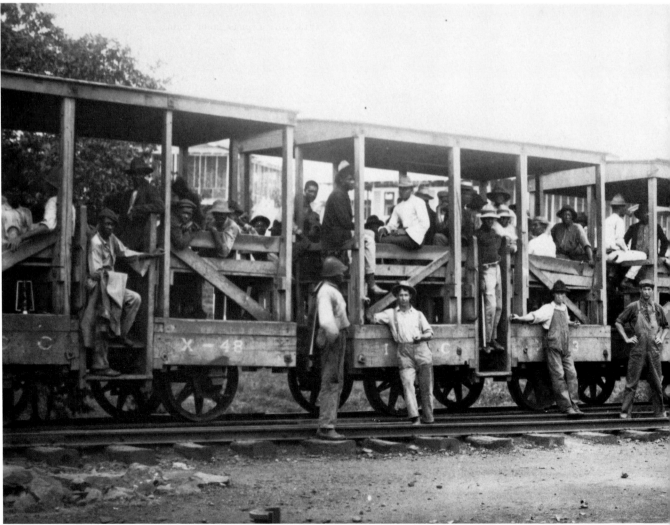

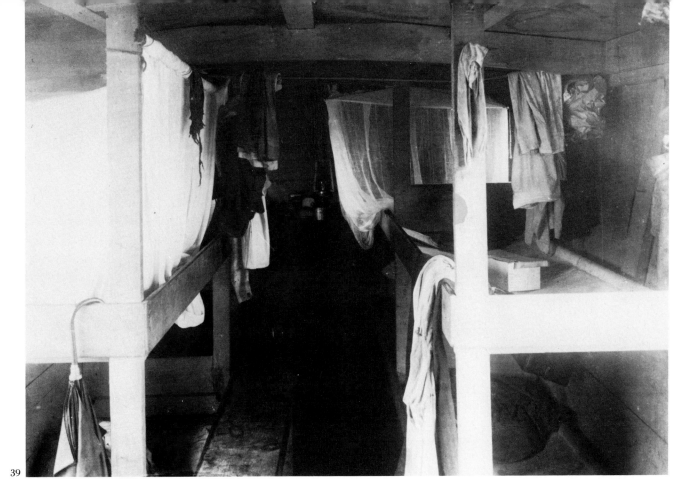

39

37. Spanish track layers eat lunch in the Culebra Cut, September 1913. 38. Typical labor train, ca. 1906. 39. Boxcar used for sleeping quarters on the Panama railroad, ca. 1906.

38

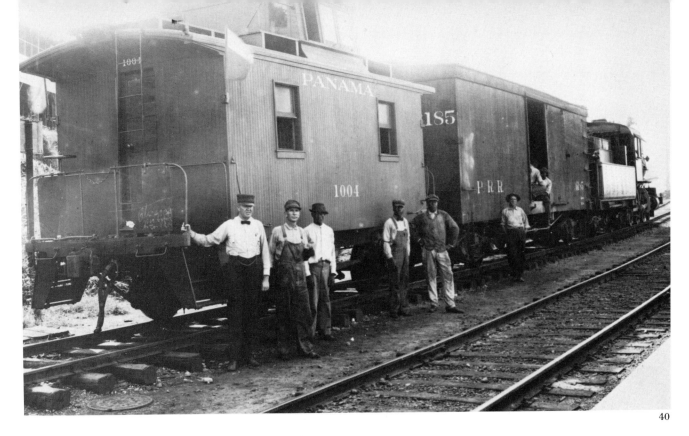

40. Typical Panama railroad caboose. **41.** A gang of 150
men shift track by hand, Culebra Cut, January 1912.

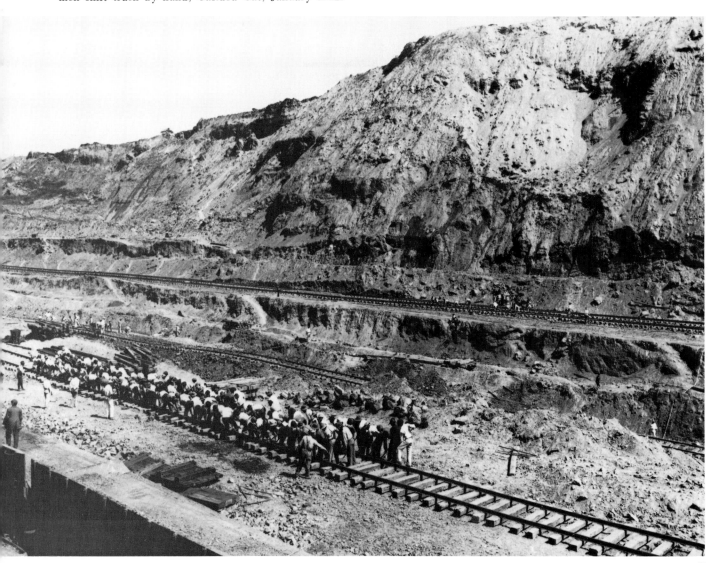

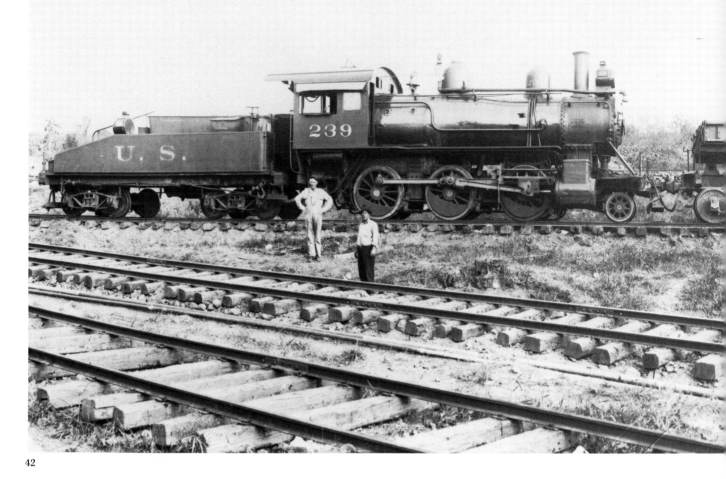

Innovation (nos. 42–45). Labor-saving devices were essential to canal construction. The Lidgerwood unloader was a plow that could be pulled across a dirt train from one end to the other, emptying it within minutes. The dump heaps thus created were flattened out by spreaders. The continuous track shifting was greatly facilitated by a special crane car that could move whole track sections at a time. With a crew of nine, each of these crane cars put 600 conventional track shifters out of work. Powerful new locomotives also helped to speed up work.

42. Cook locomotive, 200 class. **43.** McCann spreader, Miraflores dumps, 1910.

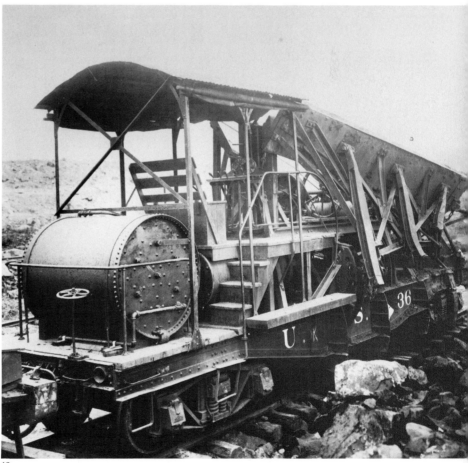

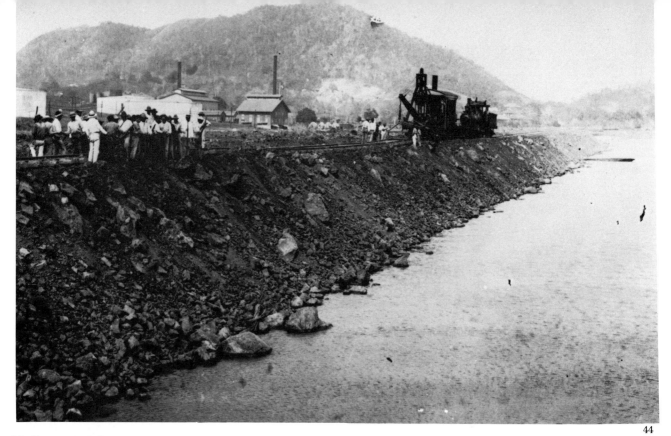

44. Crane car shifting tracks, La Boca dumps.
45. Lidgerwood unloader, Tabernilla dumps.

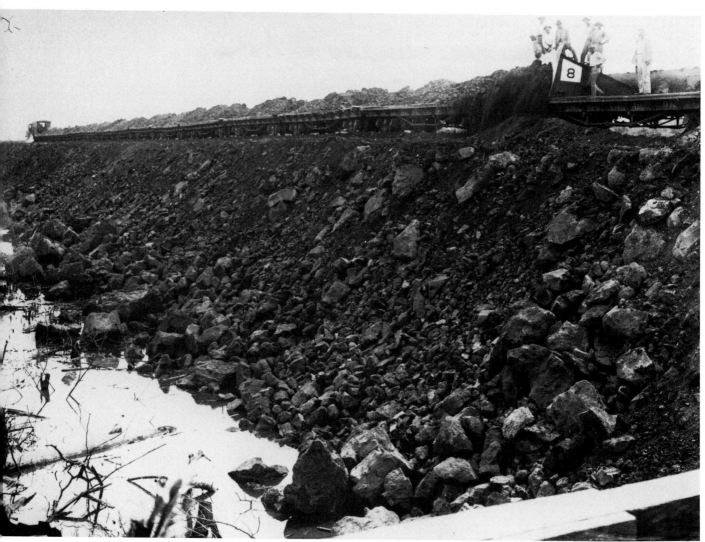

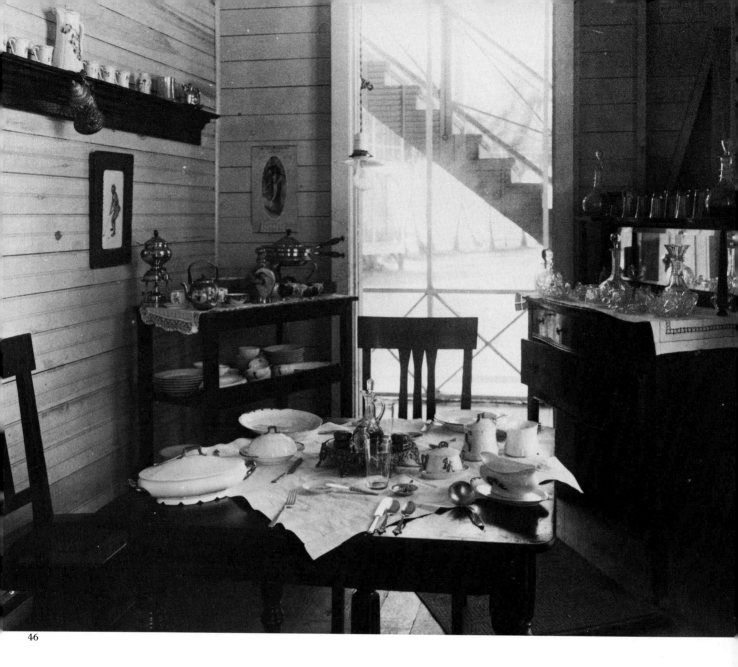

46

Infrastructure: Housing (nos. 46–49). Adequate housing in tropical conditions was another important element of the infrastructure set up by Chief Engineer Stevens in the early period of construction. All housing was provided rent-free, but there were differences in quality: white Americans lived in airy wooden structures with screened verandas; unmarried European and black laborers had to be content with unscreened mass quarters; black families could choose between American-built barracks (also unscreened and crowded) or shacks of their own in derelict native villages. Housing conditions thus became a mirror image of the social order on the Isthmus. As a contemporary observer put it: "Caste lines are as sharply drawn as in India. Every rank and shade of man has a different salary, and exactly in accordance with that salary is he housed, furnished and treated down to the last item."

46. Dining room in family quarters.

47

48

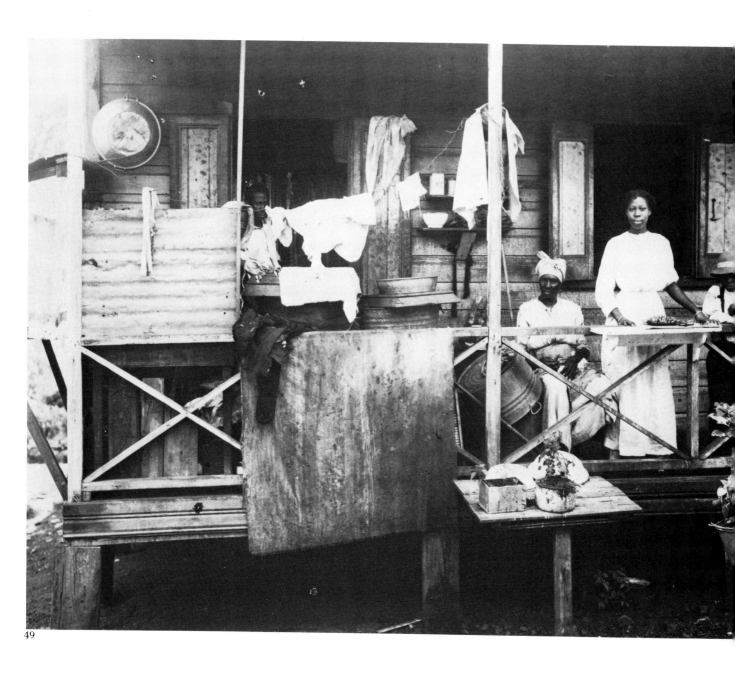

49

47. Typical bachelor quarters at Ancon. **48.** Sleeping quarters for European and black laborers. Barracks of this kind accommodated 72 men and were modeled after the U.S. Army transport plan. **49.** Typical home of West Indian laborer, Golden Green.

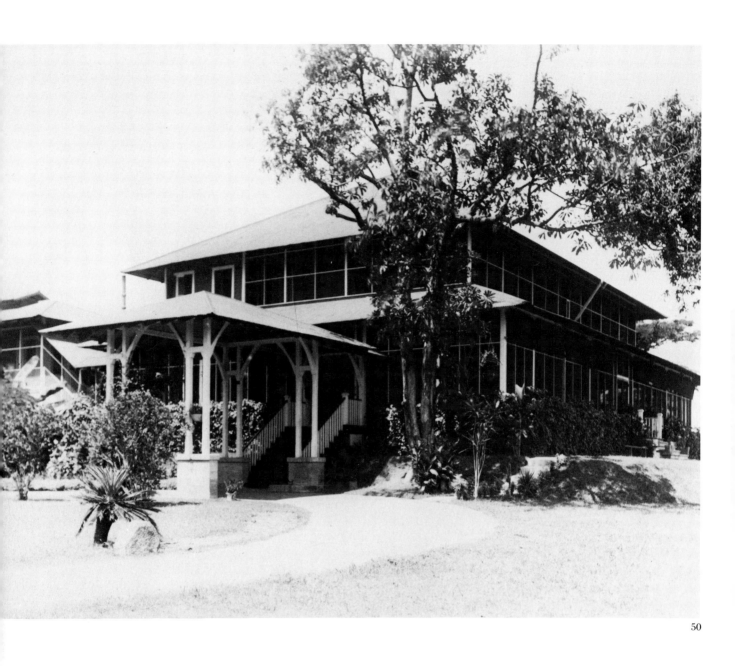

The Housing Hierarchy (nos. 50–53). Emphasizing differences in housing comfort proved to be useful in fostering a competitive spirit among the labor force. The mosquito screen, of course, was a health requirement, rather than a question of comfort. However, it was expensive because only the best copper wire could withstand the climate, and only the homes of white Americans were fitted out with screens.

50. Residence of commissary officer, Quarry Heights, June 1916. **51.** Quarters for West Indian laborers, Cristobal, ca. 1906.

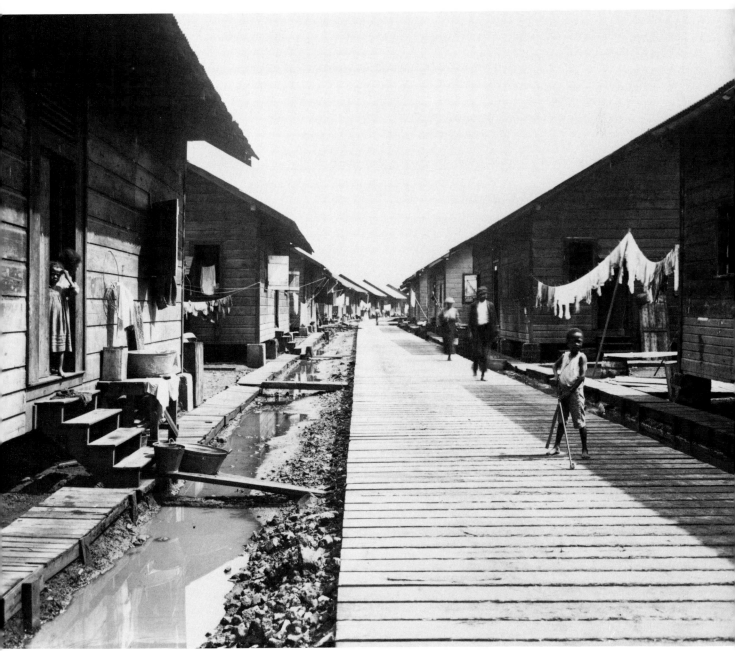

51

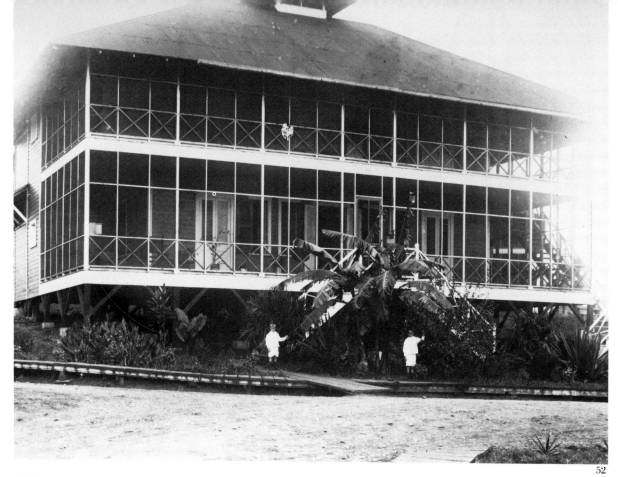

52

52. Two-family house (type 4), Culebra, 1910. **53.** Bohio village street, 1912.

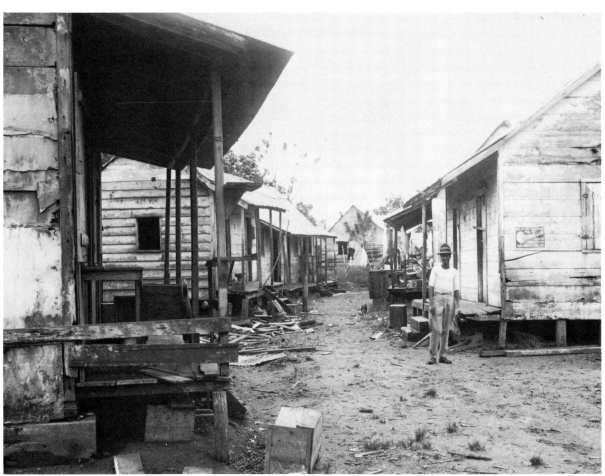

53

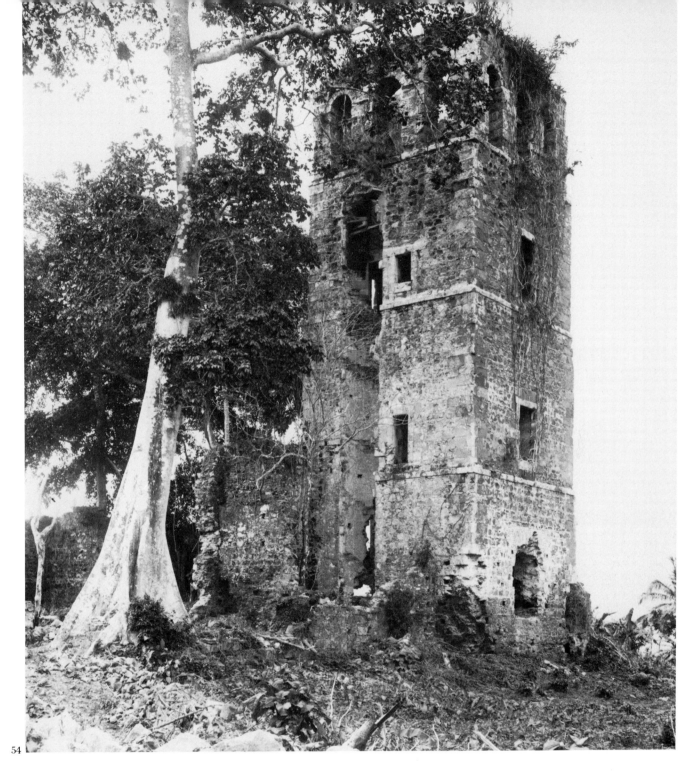

54

Panama: City and Country (nos. 54–57). What did the increasingly noticeable American presence mean to Panama itself? Since the canal was built and run by the United States, and since it served the interests of the industrialized nations, it provided limited advantages to the Republic of Panama. Moreover, these benefits were unevenly distributed. The government, the revenues, trade and commerce, schools, hospitals and amusements were all concentrated in the cities. Carnivals and bullfights flourished here, but so did gambling, drinking and prostitution—thus offering many Americans a welcome escape from puritan Canal Zone regulations. Most Panamanians, however, lived in rural areas unaffected by the sudden prosperity and corruption in the cities. Native peasants generally suffered from ill health, illiteracy, lack of land, tools and money. Even though they appeared as merry and picturesque subjects in contemporary photographs, they were among the losers of the Panama Canal venture.

54. Ruins of Old Panama: Cathedral Tower. The city of Panama became a prosperous trade center soon after it was founded by the Spanish in 1519. In 1671 it was destroyed by a buccaneer army and rebuilt on a different site, but some of the ruins are still standing.

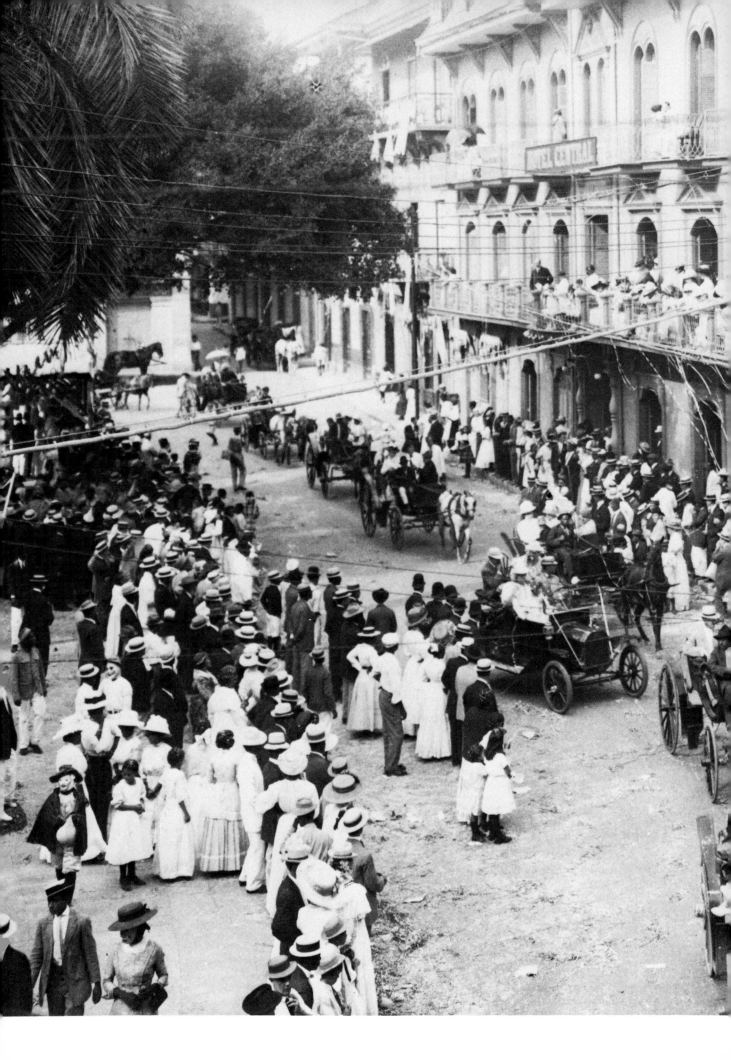

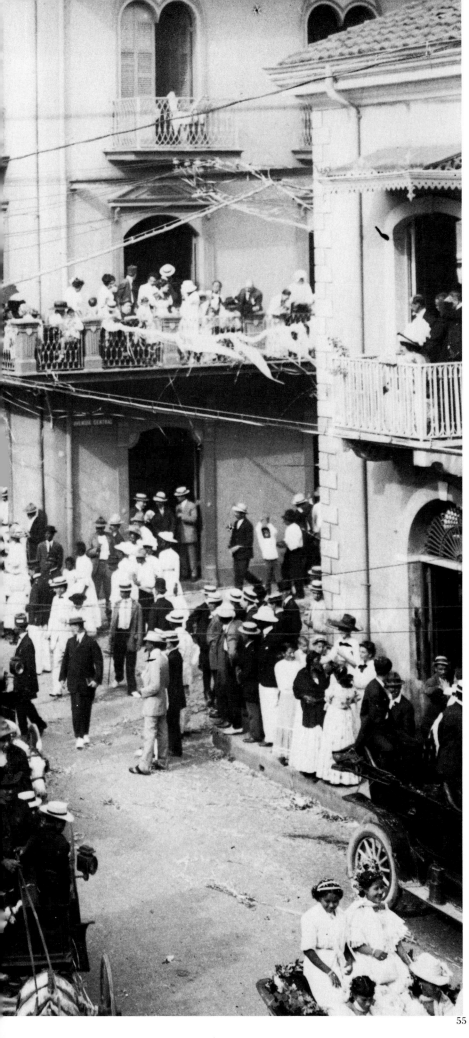

55. Cathedral Plaza, Panama City, during Carnival, February 20, 1912.

55

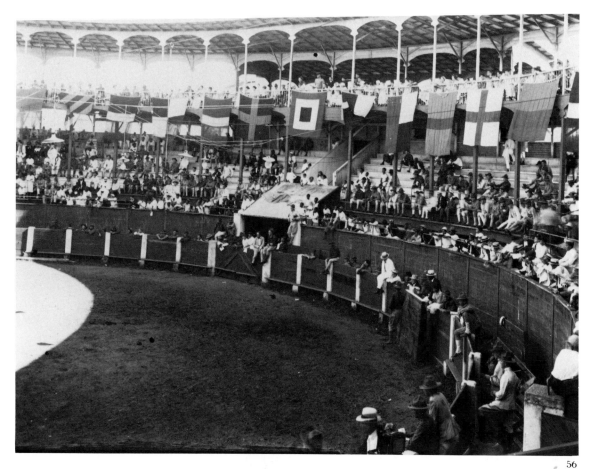

56. The bullring, Panama City, 1919. **57.** Bottle Alley before paving, Colon, September 1906. According to a knowledgeable source, this was one of the places that "served as a sort of safety valve where a canal employee could run down in an hour or so and blow off steam."

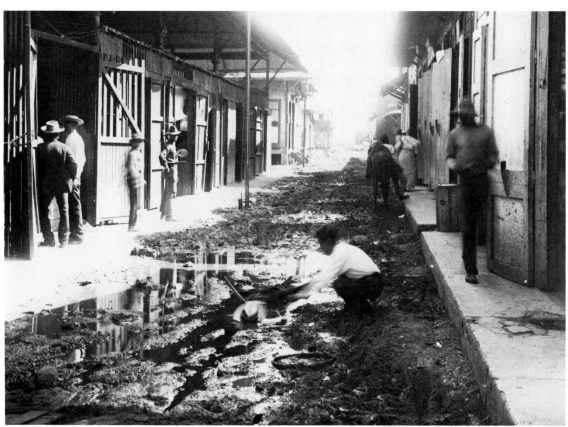

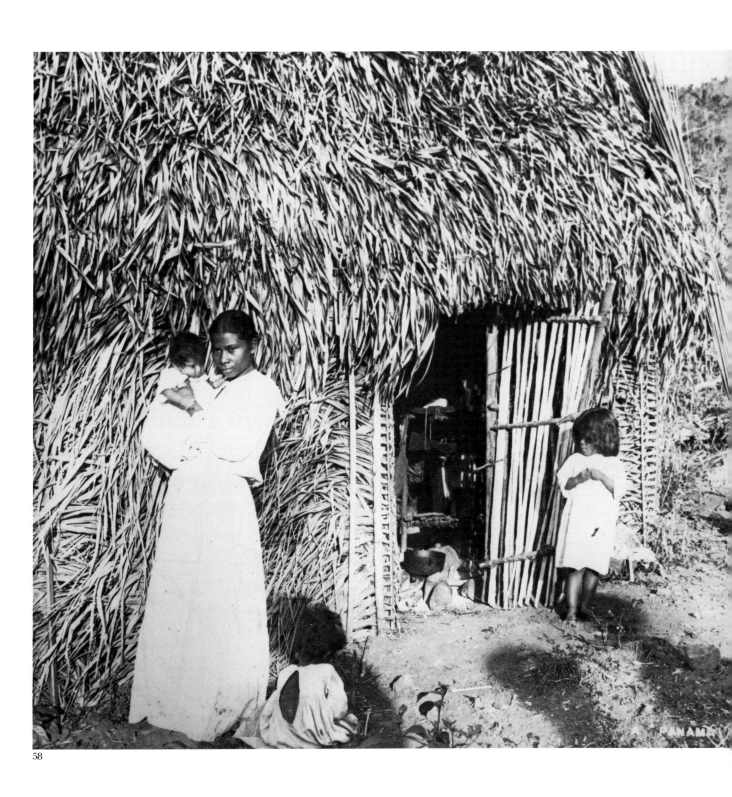

58

The First Panamanians (nos. 58–61). Most native Indians were squatters without clear land titles who practiced a nomadic form of agriculture. Under this system ("slash and burn") a piece of jungle was cleared by fire and machete to be used as a rice or corn field. Since the soil was ruined by the fire it yielded two harvests at best. After that, the peasant family abandoned reed shelter and field and moved on to a new location.

58. A Panama hut.

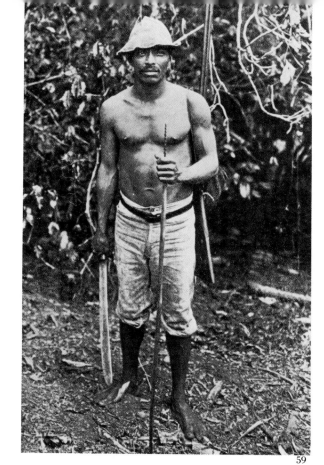

59. Panamanian Indian with machete, javelin and shotgun. 60. Washerwomen carrying tubs, 1907.
61. A native goes to market.

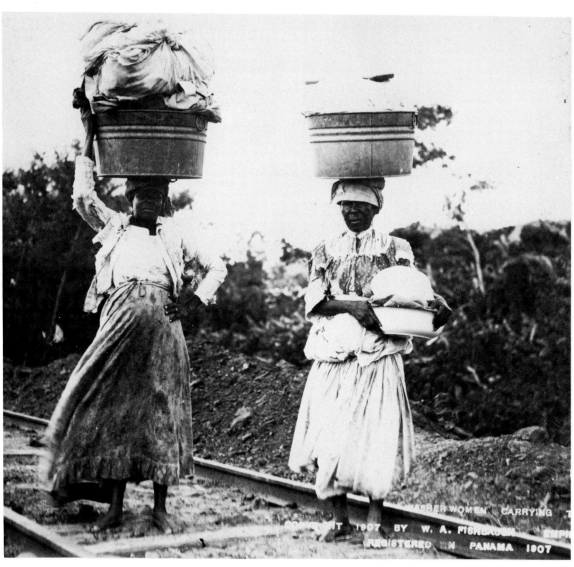

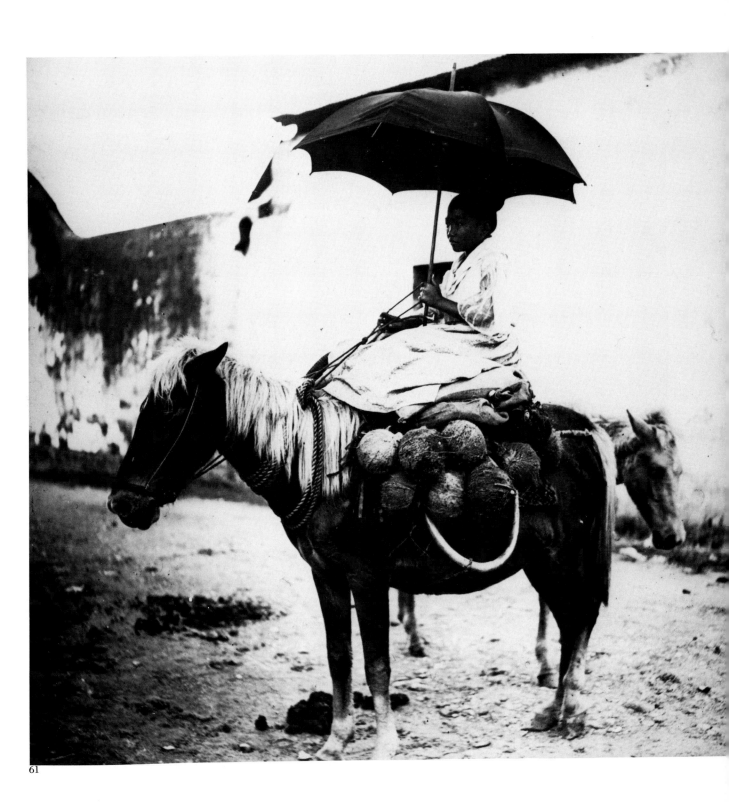

61

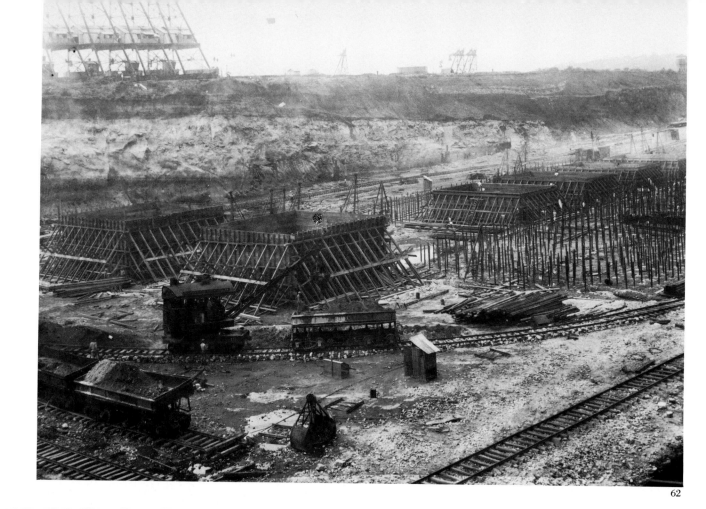

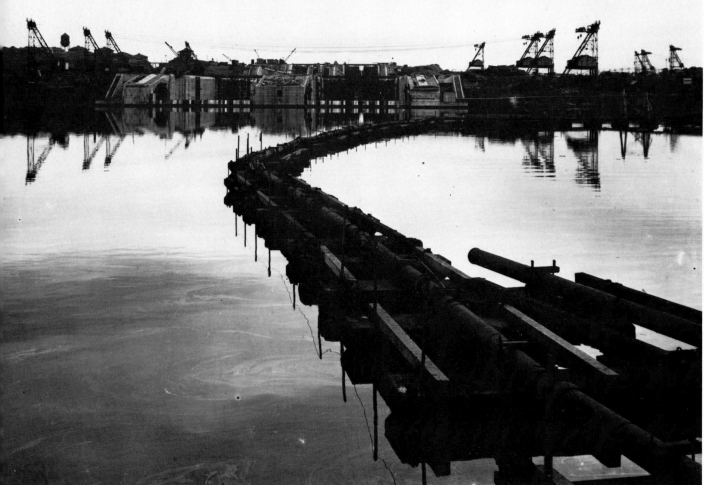

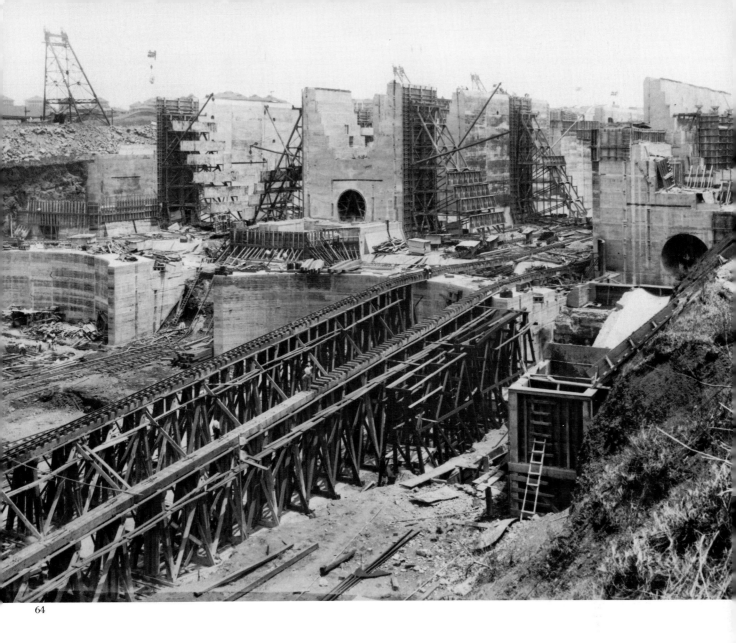

64

The Gatun Locks (nos. 62–69). Warned by the French fiasco, the Americans decided on a lock canal rather than a sea-level passage. This meant much less digging in Culebra Cut, but an additional expenditure of $60 million for gigantic concrete-and-steel structures at the various lock sites, of which Gatun, with its three levels of chambers, was the biggest. Altogether the locks required the installation of 4.5 million cubic yards of concrete, 92 steel gates, hundreds of valves and 1500 electric motors regulating the movement of water, gates and ships. Another spectacular feature was the huge culverts with a water capacity sufficient to fill the lock chambers within minutes. To accommodate two-lane traffic, the chambers were built in pairs. Their usable length and width was 1000 by 110 feet—enough to harbor the *Titanic*, had it ever made its way to Panama.

62. Gatun lock site from the east bank, August 25, 1909. The view shows the first stage of concrete placement. **63. Gatun Locks with forebay in foreground, June 13, 1912.** At Gatun, building materials were put in place by cableways which moved on tracks parallel to the locks and had a span of 800 feet. The floating pipeline in the foreground removed the mud excavated by suction dredges. **64. Gatun middle locks from the west bank, April 1, 1911.** An advanced state of construction shows steel forms used in the erection of lock walls.

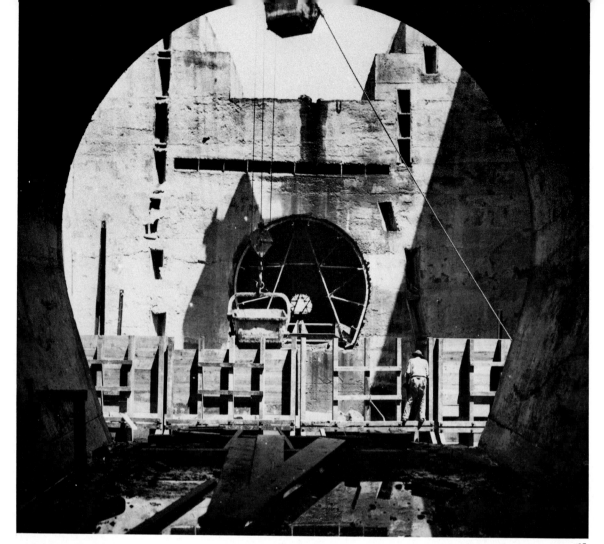

65

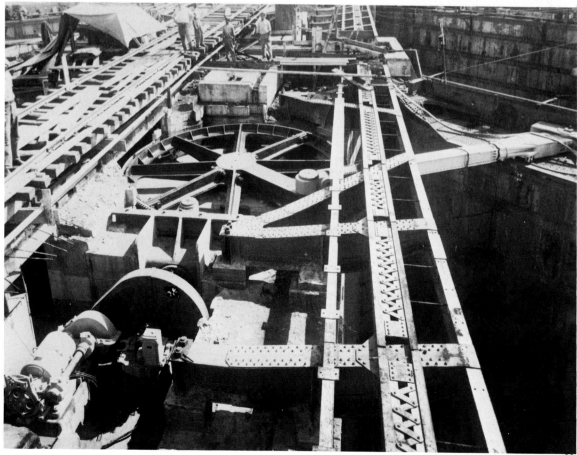

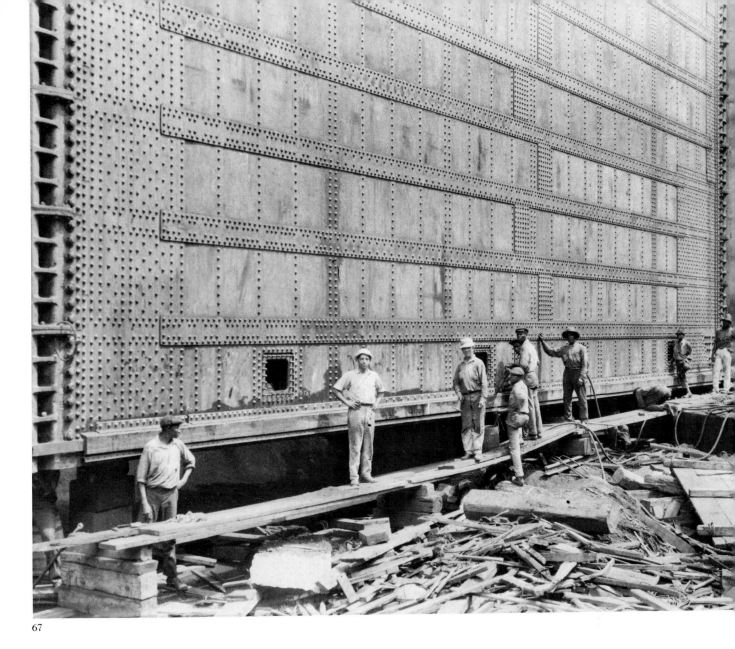

67

65. Center culvert at Gatun upper locks, October 15, 1910. 18 feet wide, these culverts were constructed by means of collapsible steel frames. In the center of the picture a cableway bucket is lowered into a mold. **66.** Miter gate-moving machine, or "bull wheel," Gatun upper locks, June 1912. The bull wheel measured 20 feet in diameter and was driven by an electrical motor with 27 horsepower. By the wheel's revolution the metal arm to the right was thrust out or withdrawn, opening or closing the gate. **67.** Making final adjustments to lock gate, Gatun lower locks, June 27, 1913. Each of these steel gates was 7 feet thick, 65 feet long, from 47 to 82 feet high and weighed between 390 and 730 tons.

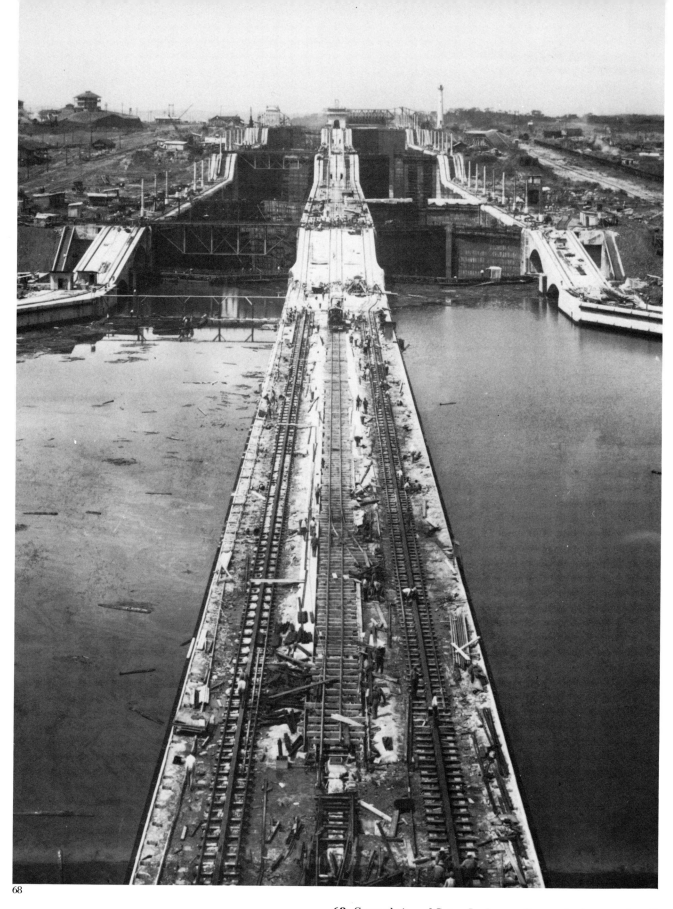

68

68. General view of Gatun Locks seen from end of approach wall, July 18, 1913. The picture clearly shows the three pairs of lock chambers bridging the 85-foot ascent between ocean level (foreground) and Lake Gatun (background). **69.** Interior view of approach wall, Gatun lower locks, May 26, 1913.

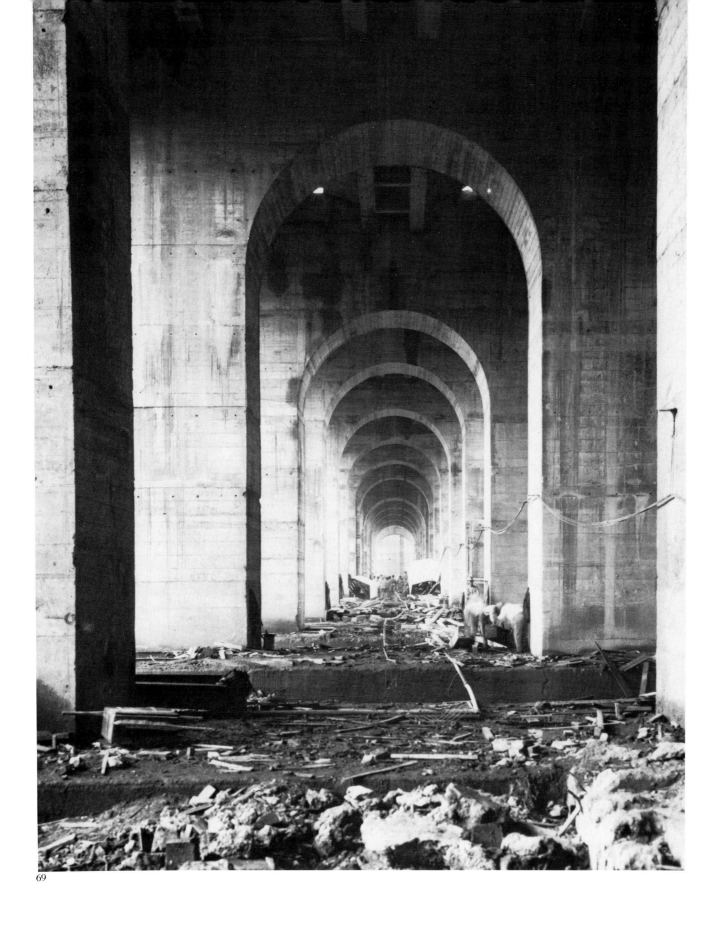

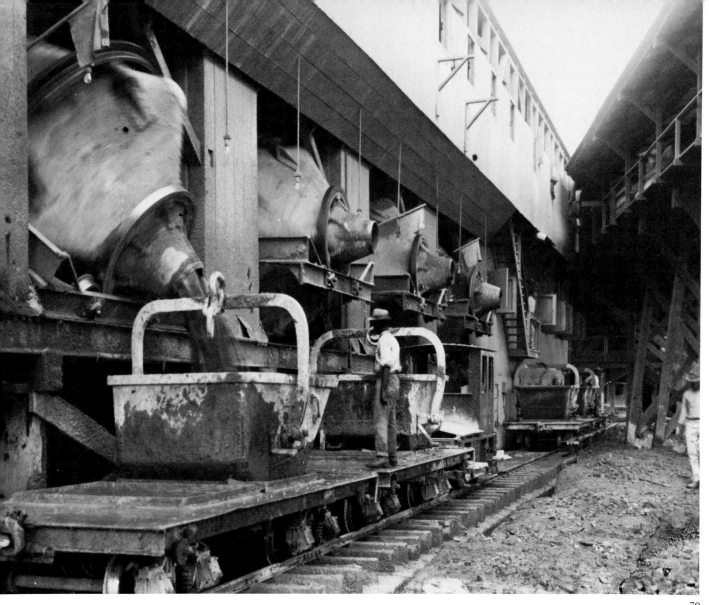

Handling the Concrete (nos. 70–73). At Gatun, storage piles of sand, stone and cement, used in making concrete, were connected with the mixing plant by means of electrical railway cars running automatically on a circular track. The mixing drums emptied their concrete loads into big buckets that were transported by railway to the cableway towers. The towers were 85 feet high and anchored 2½″ steel-wire cables with a guaranteed life of 60,000 trips.

70. Concrete mixing plant at Gatun. 71. Automatic electrical railway at Gatun: cars return empty on a 4.5 percent grade. 72. Concrete buckets brought up to head towers of Gatun cableways.

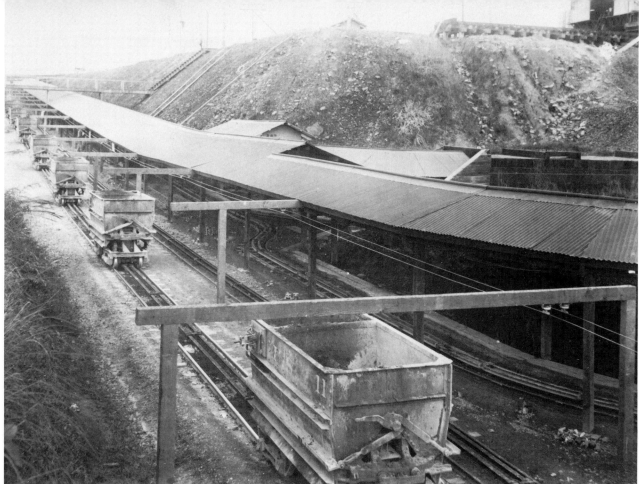

71

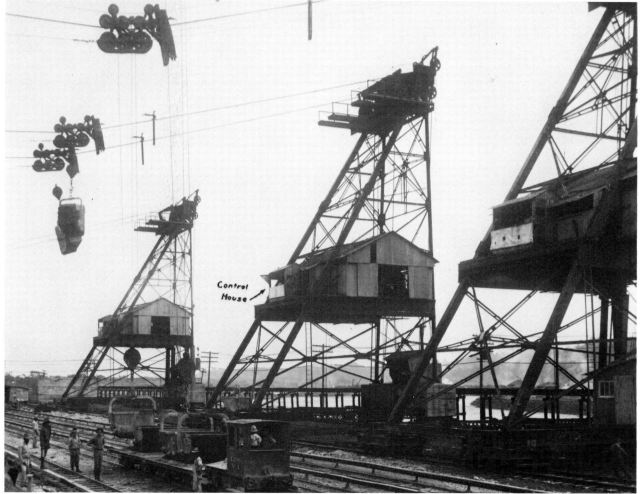

Control
House

72

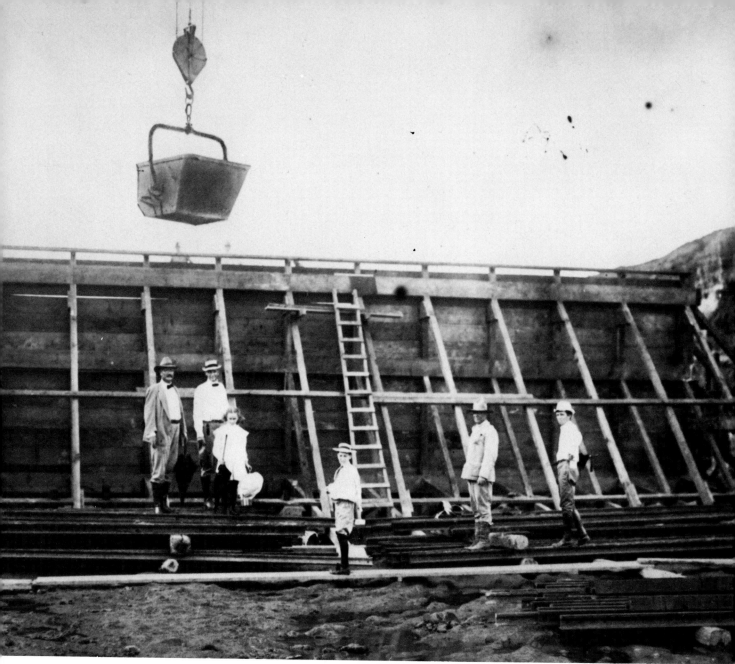

73. Gatun upper locks. The first bucket of concrete was
handled in lock construction, on August 25, 1909.

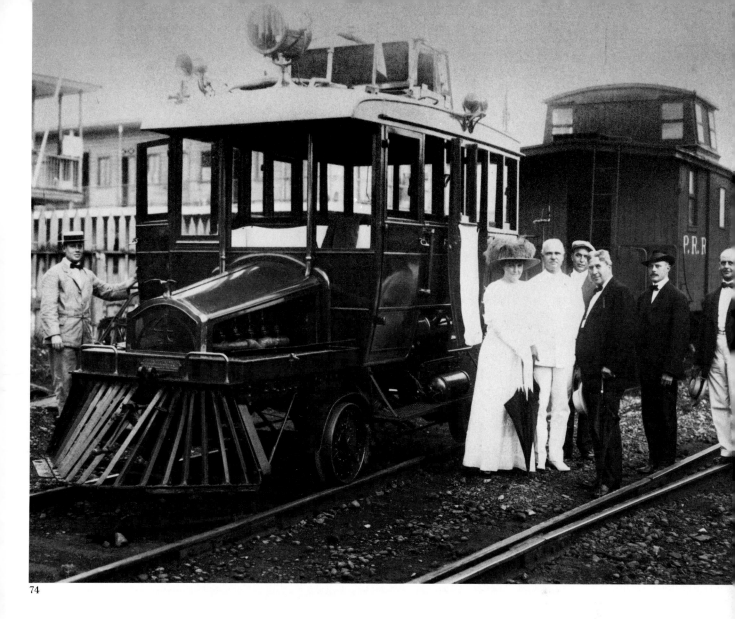

74

The Labor Force (nos. 74–80). At the high point of construction work, the American government employed over 42,000 people in Panama. Of these employees, 5,600 were white Americans (called "gold employees" because their salaries were paid in American gold dollars). The "silver employees" (those paid in Panamanian silver) comprised 4,200 European laborers and 33,500 West Indians, most from Barbados and Jamaica. Annual salaries for white Americans ranged from $900 to $7,200; $380 to $480 for European laborers; $240 to $320 for blacks. Similar gradations were evident in the quality of food, laundry service, medical care, vacation privileges and other living conditions. Altogether the Panama Canal was an attractive project that offered each class of employee a higher income than could be expected at home. At the same time, workers had to live with considerable inconveniences and health risks, which accounts for the unusually large turnover in the labor force.

74. Panama Canal Car No. 4 with Col. and Mrs. Goethals. Used for unannounced inspections all across the Isthmus, the Chief Engineer's car, with its yellow roof, was known as the "yellow peril."

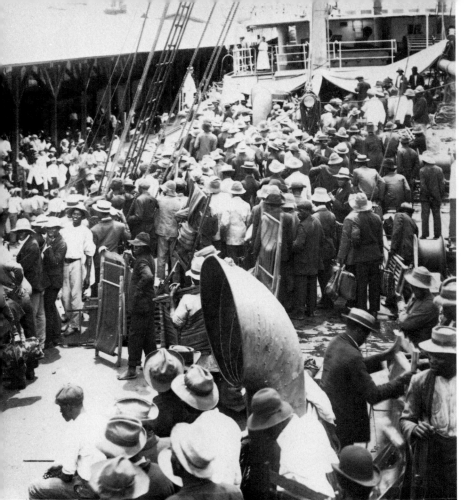

75. Arrival at Cristobal of S.S. *Ancon* with 1500 laborers from Barbados, September 2, 1909. At first, cargoes of "black ivory" had to be secured by recruiting agents since the deadly working conditions under the French were too well remembered. Later there was a voluntary influx of West Indian labor. **76.** Construction forces reerecting houses removed from areas to be flooded, Corozal, April 1913. Characteristically, black and white laborers pose in two strictly segregated groups. **77.** Dinner time in I.C.C. (Isthmian Canal Commission) hotel, Gorgona, ca. 1906. **78.** Mealtime at I.C.C. kitchen, upper Rio Grande, ca. 1906.

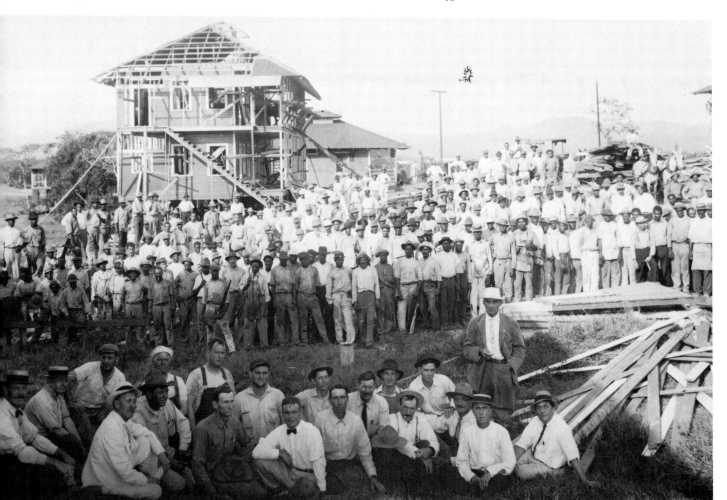

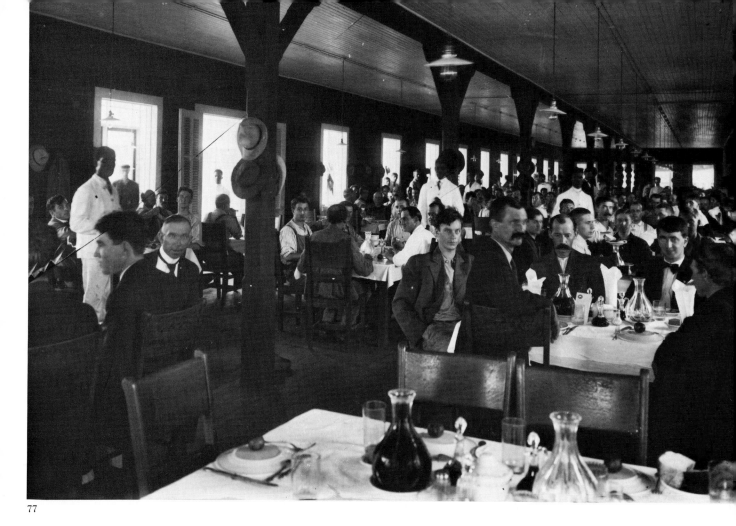

77

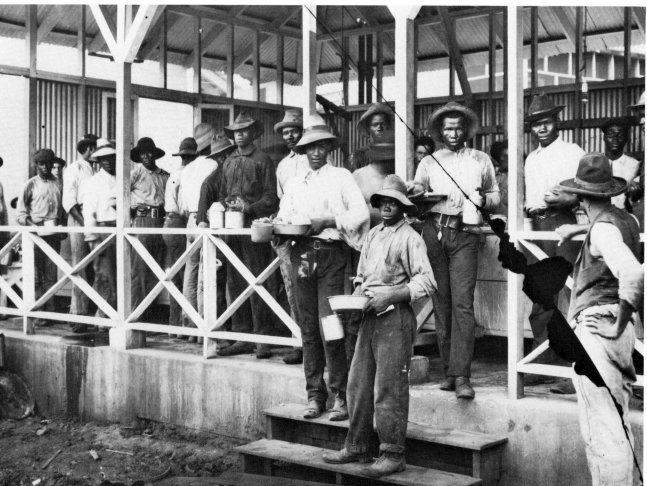

78

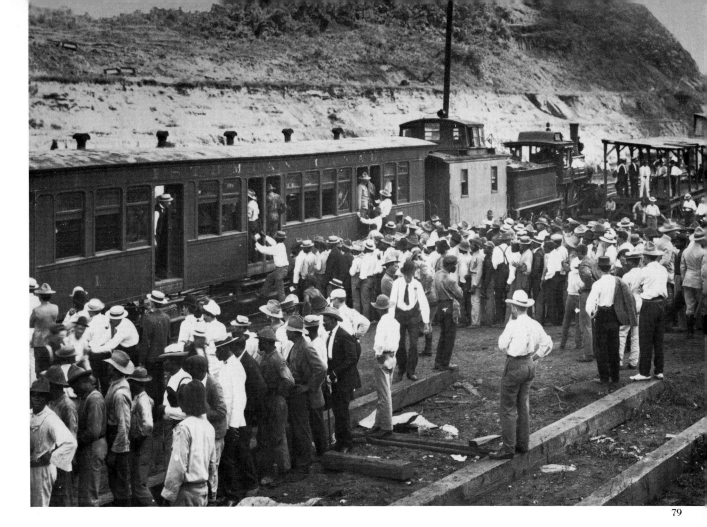

79. The pay car at Culebra, January 12, 1908. **80.** Interior of an I.C.C. pay car.

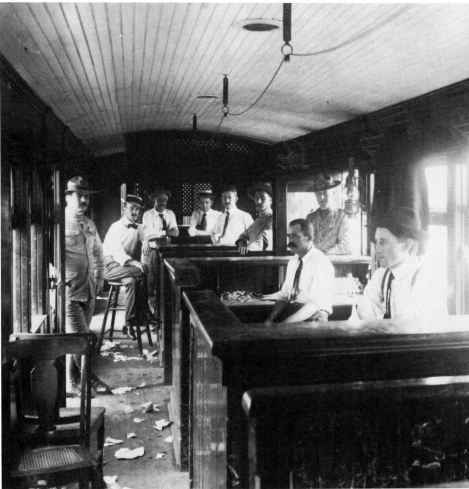

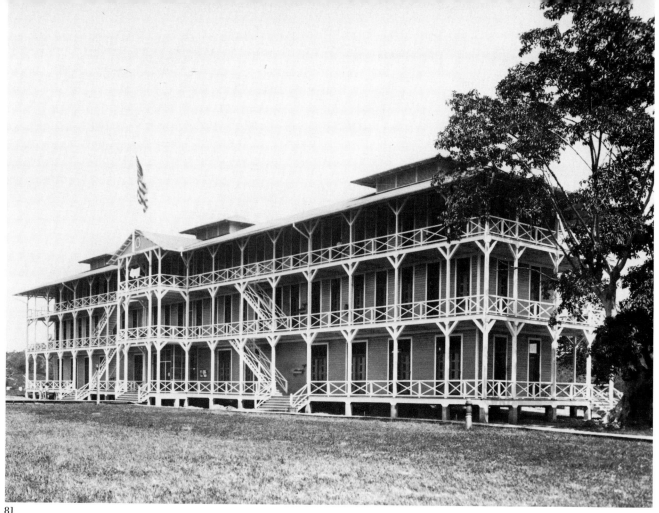

81

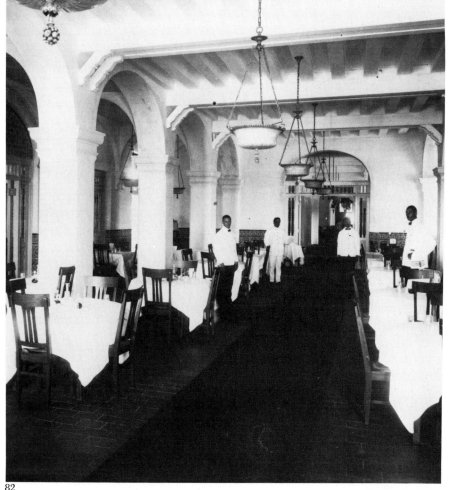

82

Feeding an Army (nos. 81–84). The labor force was fed as unequally as it was housed. White Americans dined in I.C.C. "hotels" for 30 cents per meal, on which the government lost money. European laborers ate in "mess tents" for 13⅓ cents per ration, while black laborers received their rations at 9 cents in corrugated iron "kitchens." The government made a profit on these rations, and was unhappy when some Europeans and most West Indians began to cook their own meals.

81. I.C.C. hotel (with restaurant) at Corozal. **82.** Dining room for tourists in the Washington Hotel, Colon, 1913.

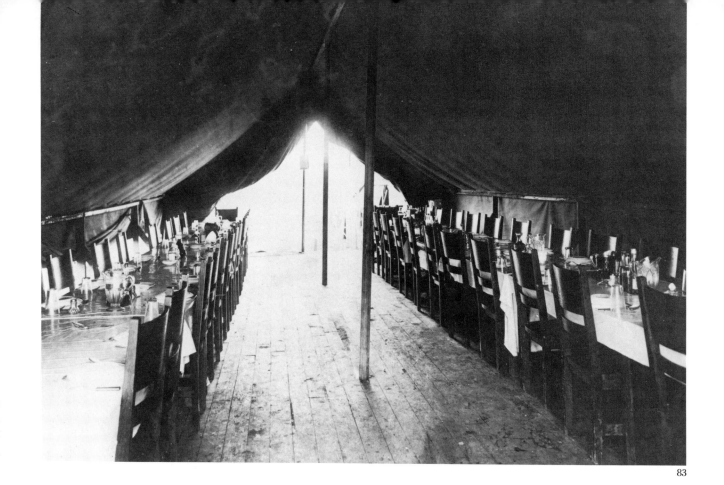

83

84

83. Interior of mess tent for European laborers, October
1906. **84.** I.C.C. kitchen for black laborers near Gorgona.

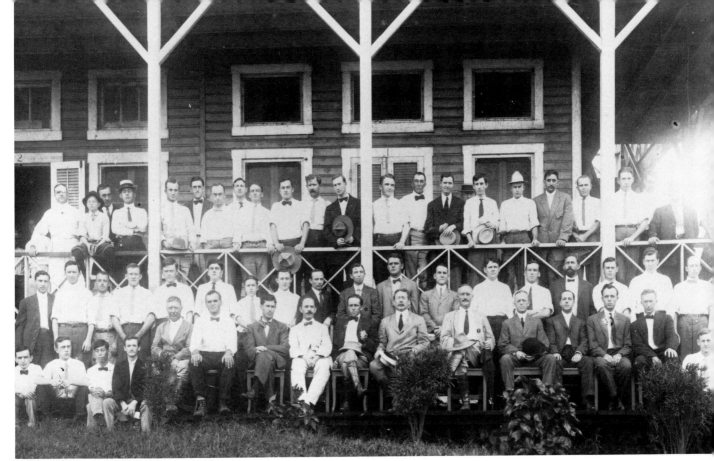

85

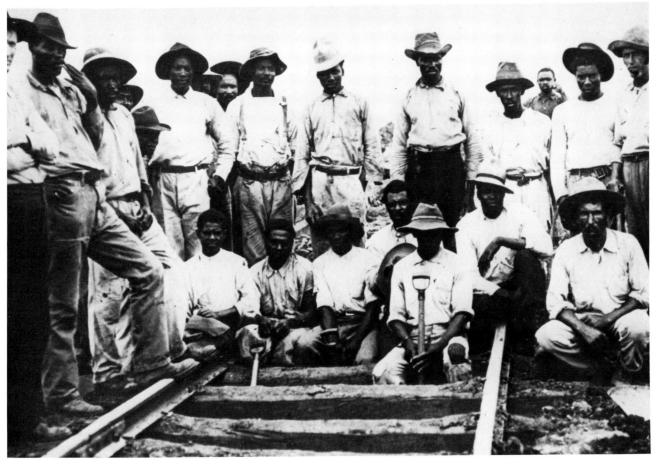

86

International Labor Force (nos. 85–88). The canal army included workers from 47 different nations, the bulk coming from the United States, Jamaica, Barbados, Spain, Italy and India. European crews were brought to the Isthmus in order to demonstrate to the West Indians that they could be replaced.

85. Group of American engineers. **86.** Group of West Indians.

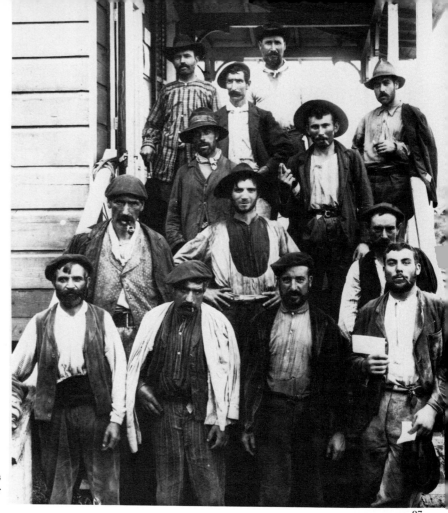

87. Group of "Gallegos" (Spaniards) at Las Cascadas. 88. Hindu laborers waiting for their pay, Balboa, June 11, 1913.

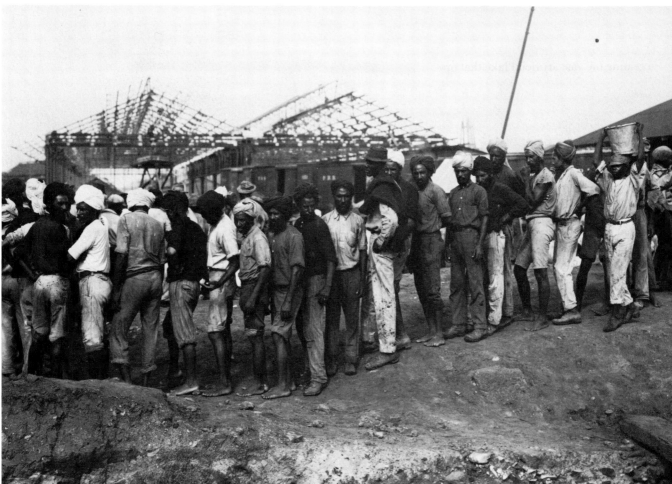

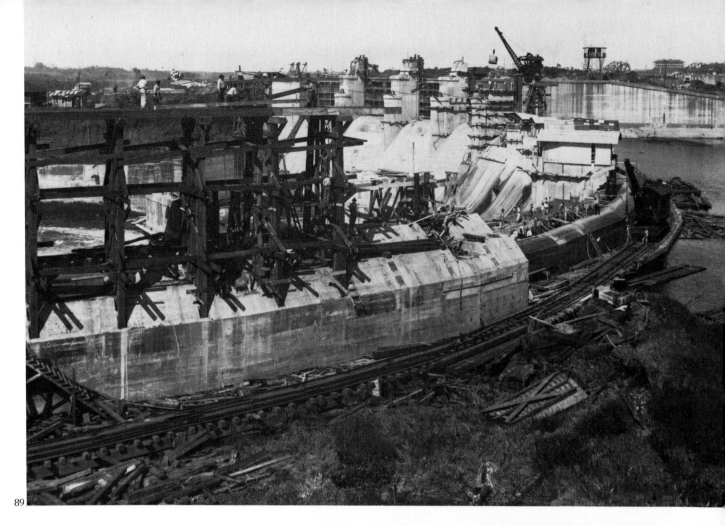

89

The Gatun Dam (nos. 89–92). As one of the key elements in the canal, Gatun Dam serves two important purposes: it cuts off the Chagres River, creating the vast artificial lake that provides a path for ships across most of the Isthmus; and it is linked to a hydroelectric station with a capacity of 6000 kilowatts, enough to keep the complex electrical lock mechanism in motion and to light the Canal Zone. Gatun Dam consists of rock and earth material that was piled up for years at a rate of 100 trainloads per day. The dam is 2700 feet wide at the bottom, 105 feet high and 7500 feet long. In the center it has a concrete spillway with huge floodgates of steel sheathing that serve to keep the lake at the desired level of 85 feet.

89. Gatun Spillway Dam under construction, January 3, 1913. The spillway's main feature is a series of 13 concrete piers that stand 115 feet above sea level and hold the regulating steel gates in place. **90.** Penstocks at head gates, Gatun Hydroelectric Station, July 15, 1913. At this point the water drops 75 feet into great turbines.

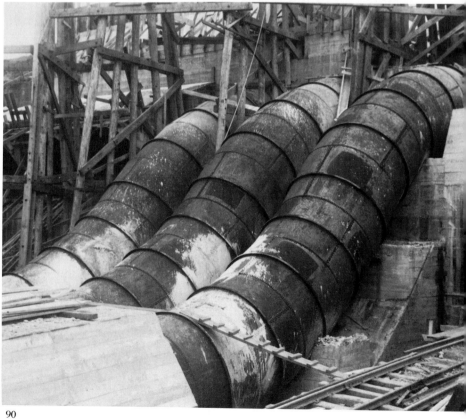

90

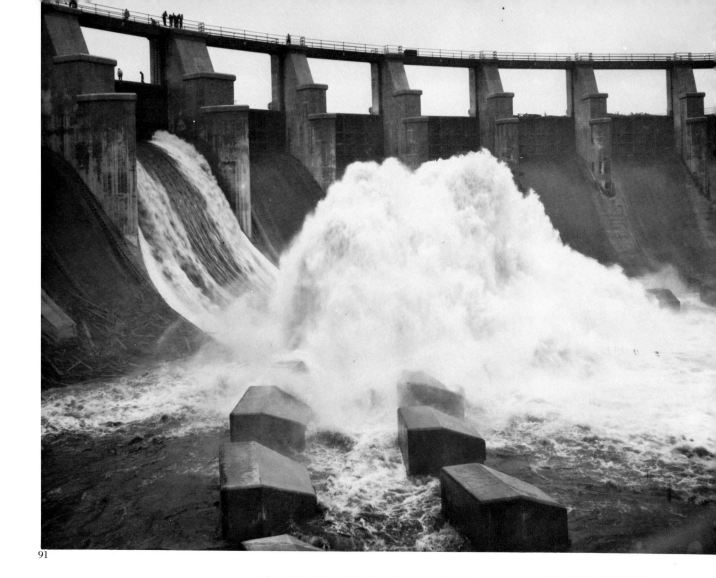

91

91. Testing crest gates of Gatun Spillway Dam, December 27, 1913. To break the power of the water torrents, the water is made to converge on the bottom of the spillway. Steel-plated baffle piers also have a slowing effect. **92.** Concrete train leaving machinery tunnel in Gatun Spillway Dam, ca. 1913.

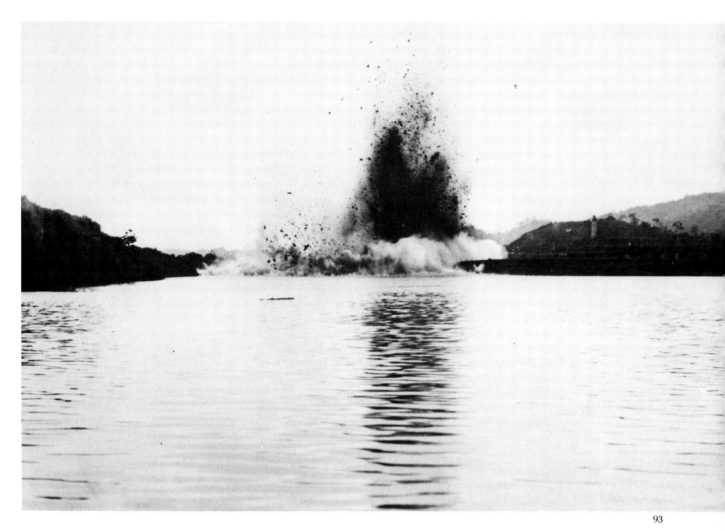

93

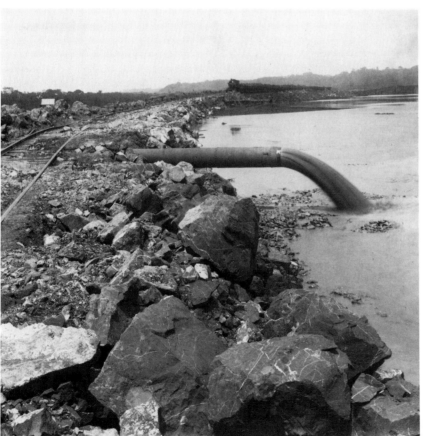

A Man-made Lake (nos. 93–96).
Gatun Dam was built in the form of two parallel rock barriers with many million cubic yards of liquid silt pumped in between. Dried and hardened, the silt made a core as durable as concrete. When President Wilson pushed a button in the White House on October 10, 1913, a subsidiary dike at Gamboa blew up and Gatun Lake began to extend over an area of 164 square miles, sprinkled with dying jungle trees and navigation towers.

93. Blowing up Gamboa Dike, October 10, 1913. **94.** Dirt train and silt pump filling up the core of Gatun Dam, July 1911.

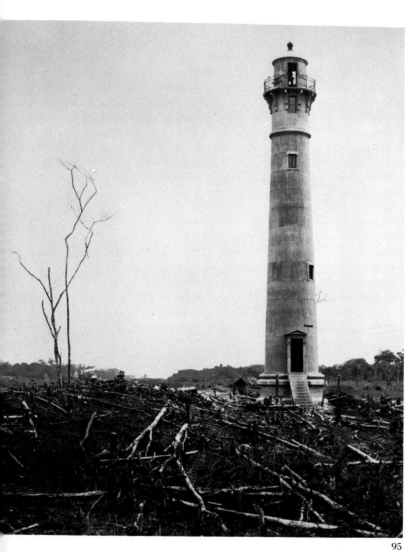

95

95. A 74-foot-high range tower marks the future navigation channel, July 14, 1912. **96.** Dying jungle vegetation in Gatun Lake, February 1919.

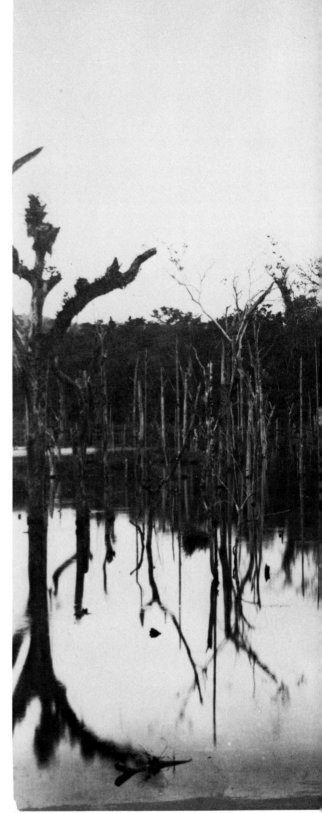

96

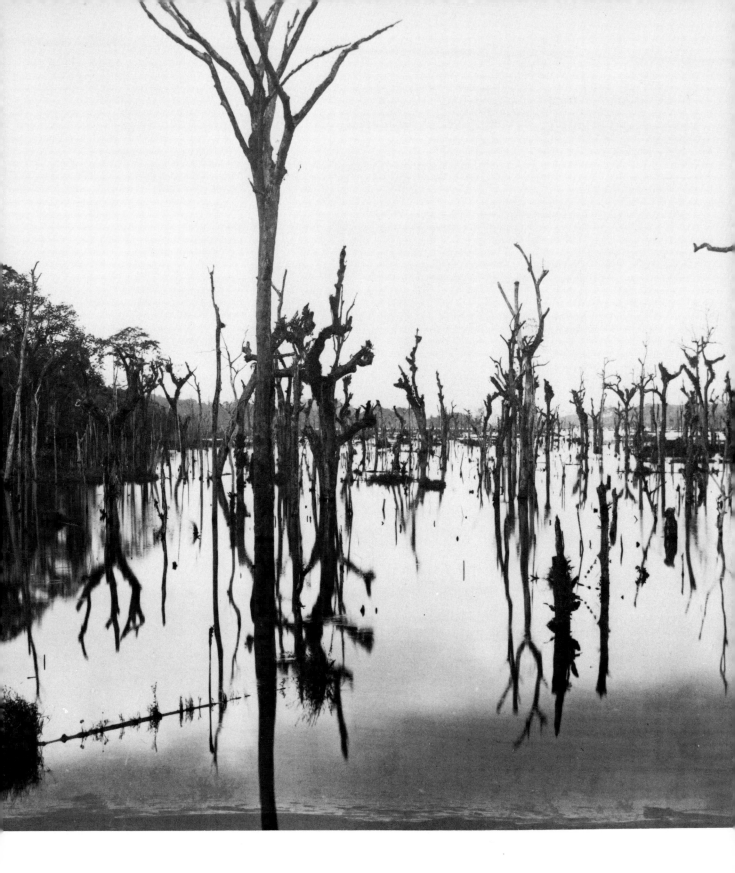

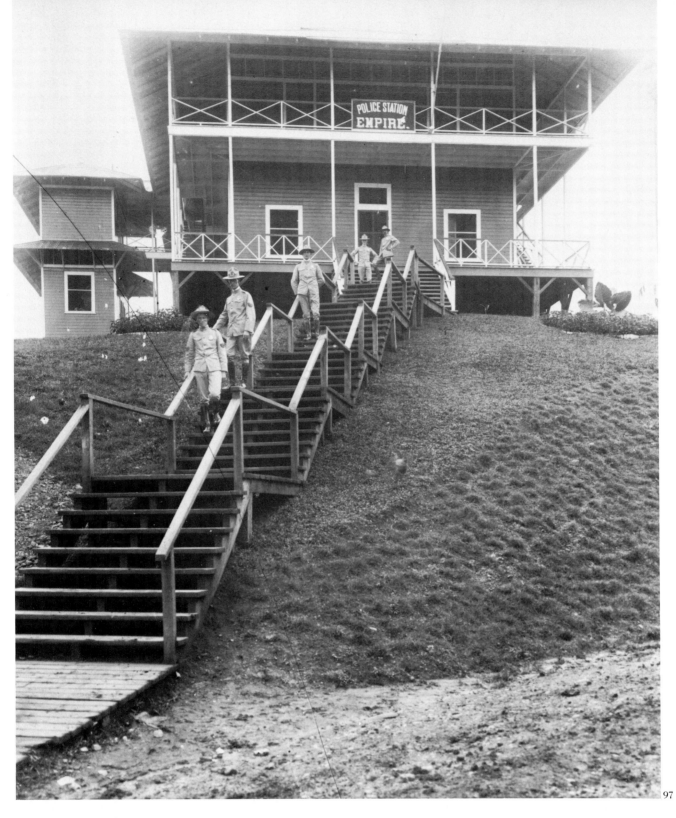

Administration and Supplies (nos. 97–103). The presence of 65,000 employees and their families required the organization of a complete miniature government in the Canal Zone. Courts, post offices, police forces, fire departments and schools were all part of the canal administration. In addition, the government (i.e. the Isthmian Canal Commission headed by Col. Goethals) kept the canal force supplied with food and other necessities. The Commissary Department built its own ice-cream plant, bakery and coffee-roasting facility and created a banana plantation. However, most items were imported along a refrigerated-supply line from Chicago and New York to Cristobal. From there, a refrigerated train started every morning across the Isthmus, and by 8

o'clock every household had received its daily ration of bread and ice. In spite of the transportation problem, prices were reasonable because the I.C.C. sold most items at cost.

97. Police station at Empire, ca. 1906. The Americans maintained a police force of 240 men on the Isthmus. **98. Group of policemen at Empire, 1913.** According to contemporary reports, the Canal Zone police was a well-organized body of "high intelligence and excellent carriage." Garbed in khaki and boots, the men had more resemblance to the cavalry than to ordinary police. **99. The fire station at Cristobal.** The Division of Fire Protection included a Fire Chief, an Assistant Fire Chief, seven captains, seven lieutenants and 41 firemen.

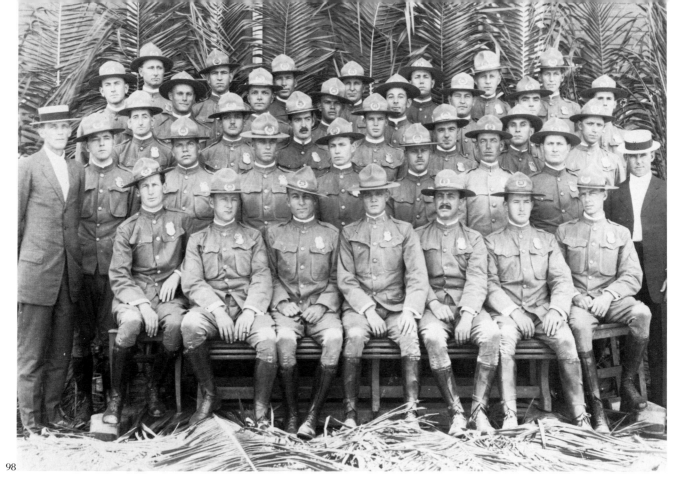

98

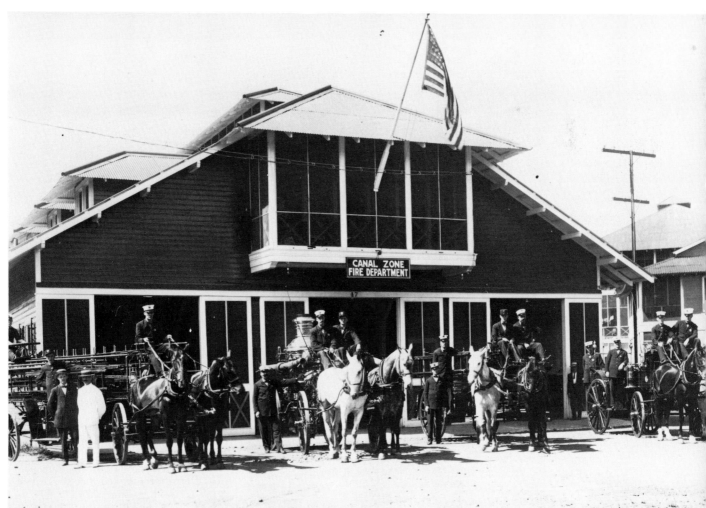

99

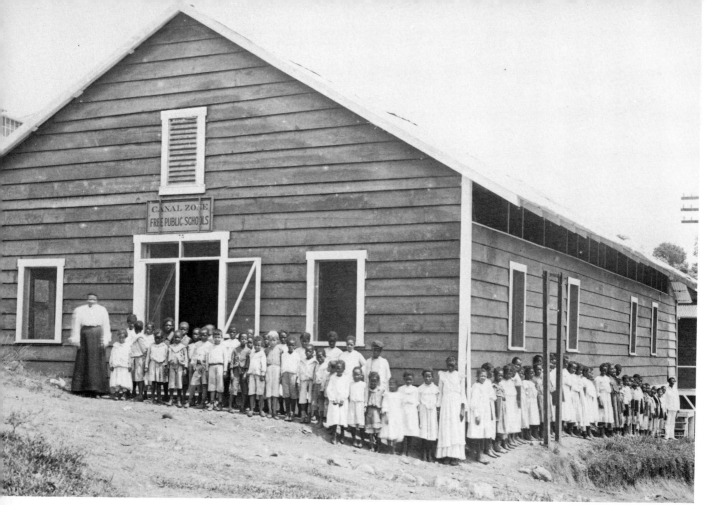

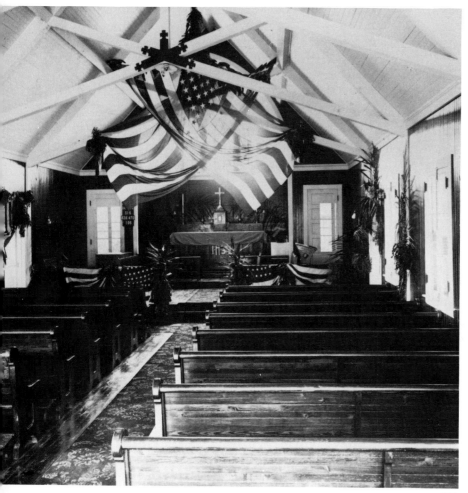

100. Free public school, Culebra, 1905. The Americans established free, but segregated, schools in the Canal Zone. 101. Interior of St. Luke's church, Ancon, 1909. 102. Commissary Department laundry at Cristobal, 1911. In a record year, 3.5 million pieces were laundered here. As everyone knew, there was "no come-back for the garment that is not hardy enough of constitution to stand the system." 103. Commissary Department bakery at Cristobal, 1910. The Commissary Department baked for the whole canal army—6 million loaves of bread, 650,000 rolls and 114,000 pounds of cake per year.

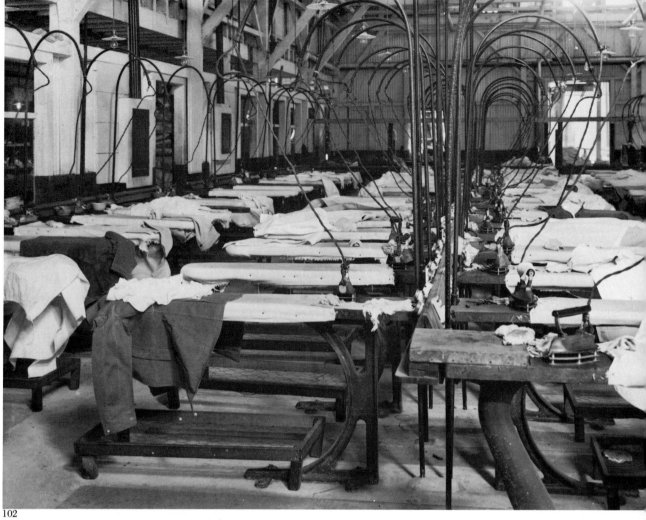

102

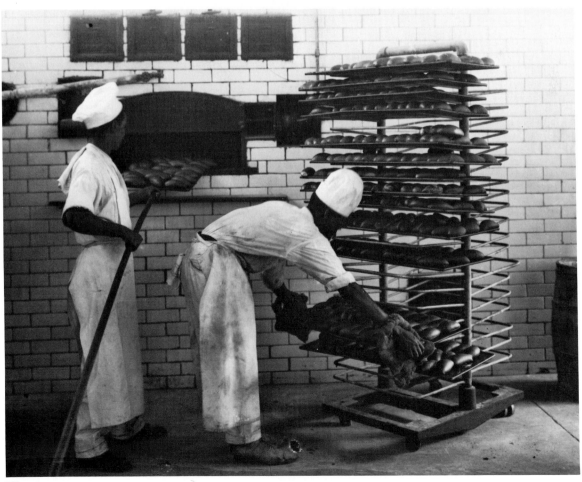

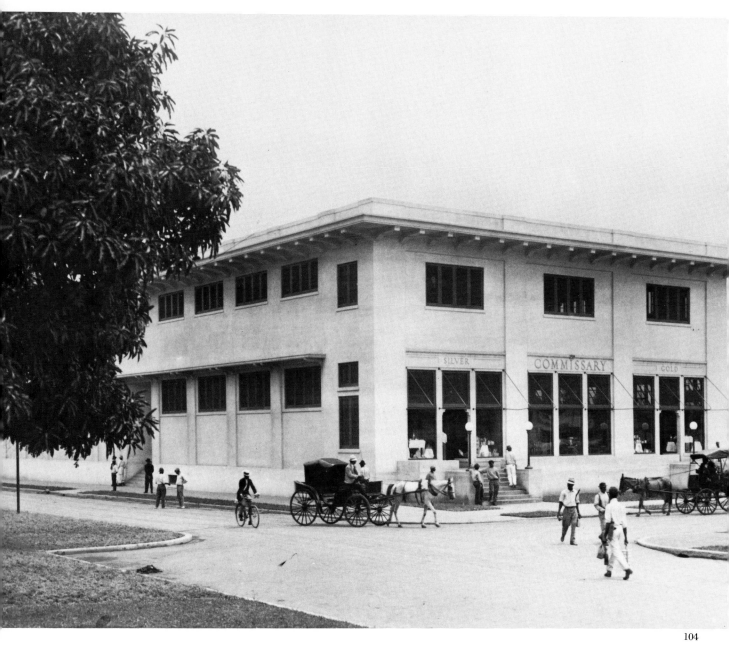

The Commissary System (nos. 104–107). Commissary stores were subdivided into two sections—for "gold" and for "silver" employees. Commissary clerks were notorious for working "in the most languid, unexcited manner." A cold-storage plant and a banana plantation provided the labor force with special treats.

104. Commissary store at Balboa, June 1915. **105.** Ice delivery wagon in front of cold-storage plant at Cristobal, 1910.

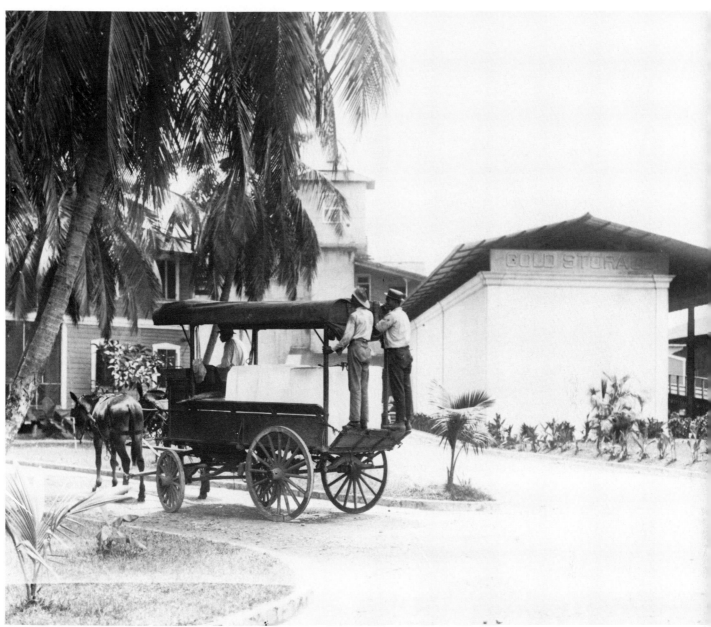

105

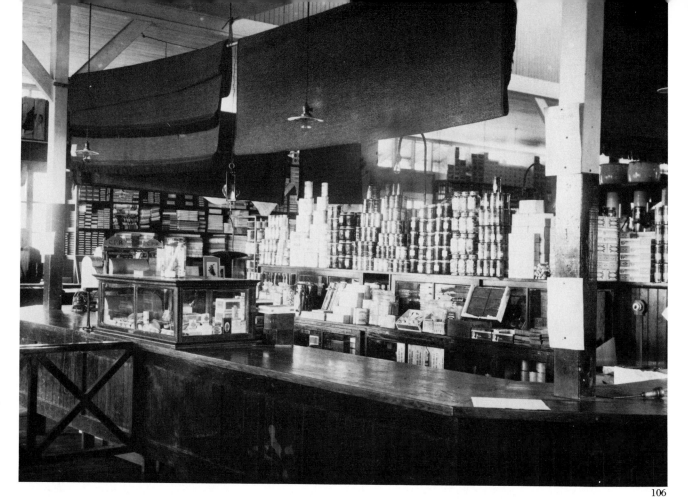

106. Interior of Commissary store at Gatun, 1911.
107. Banana plantation on Chagres River, 1918.

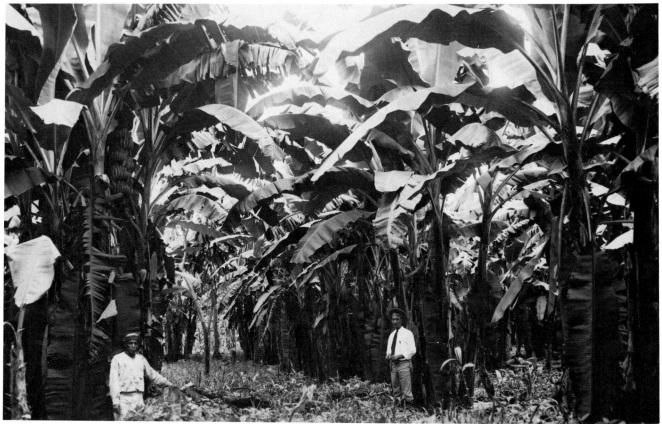

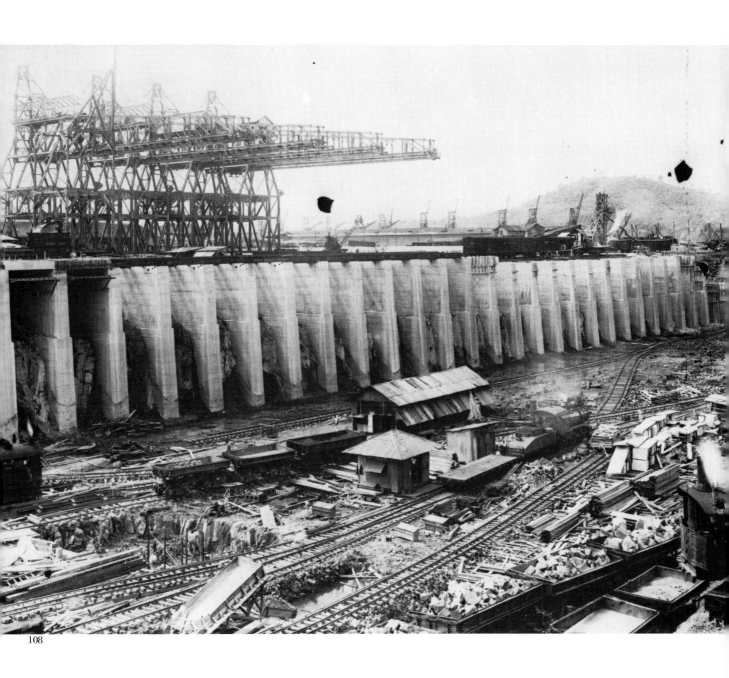

108

The Terminals (nos. 108–111). Supply facilities were essential both for the permanent American forces on the Isthmus and for the international ship traffic. Consequently, a whole array of piers, dry docks, coaling plants and depots mushroomed around the harbors of Cristobal (Atlantic side) and Balboa (Pacific side).

108. Unloader wharf piers for the coaling plant, Balboa Terminals, February 23, 1915.

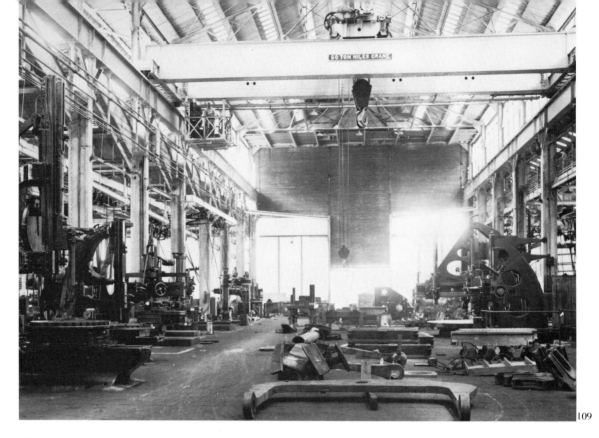

109

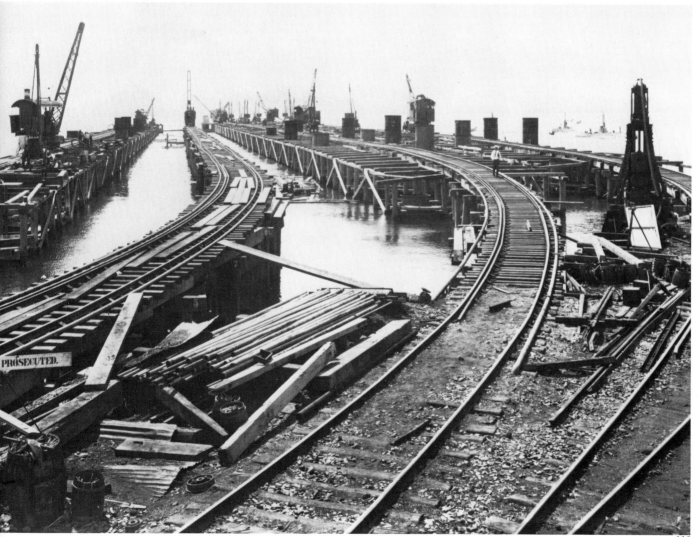

110

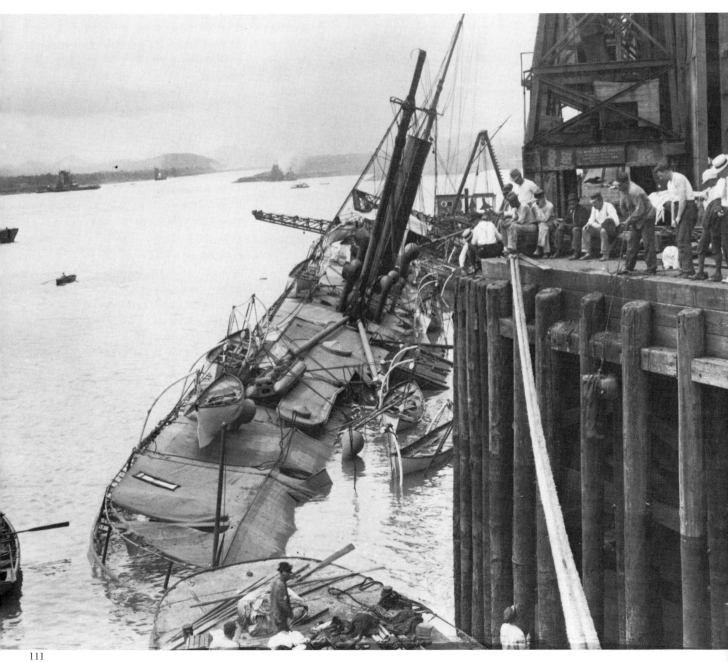

111

109. Interior of machine shop, Balboa Terminals, August 20, 1914. **110.** Trestle construction for Pier 7, Cristobal, January 29, 1915. **111.** Sinking of steamship *Newport* following collapse of the old wharf, Balboa, August 17, 1912.

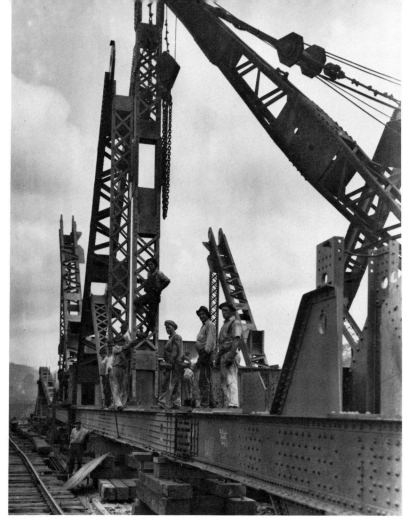

Pedro Miguel and Miraflores (nos. 112–120). On the Pacific side, the locks were divided into a single pair at Pedro Miguel and a double pair at Miraflores. In both locations the concrete was placed by huge traveling cranes, rather than by cableways. As at Gatun, the lock walls were 81 feet high and up to 60 feet wide. The chambers could be filled or emptied within 7 to 15 minutes, allowing ships to pass from one level to the other in 30 minutes or less. The passage from ocean to ocean lasted between 8 and 10 hours. All locks were equipped with elaborate safety features such as emergency gates, dams and chains, as well as specially designed switchboards which made improper operation impossible. As a contemporary expert noted, the canal was constructed "for a 100 million people and for generations yet unborn, and 'safety' was the pole-star of its builders."

112. Emergency dam under construction at Pedro Miguel locks, April 4, 1913. 113. Pedro Miguel lock site seen from west bank, October 29, 1909. 114. Pedro Miguel lock site seen from west bank, August 30, 1910. 115. Pedro Miguel lock site during flood, seen from south end, December 4, 1910.

112

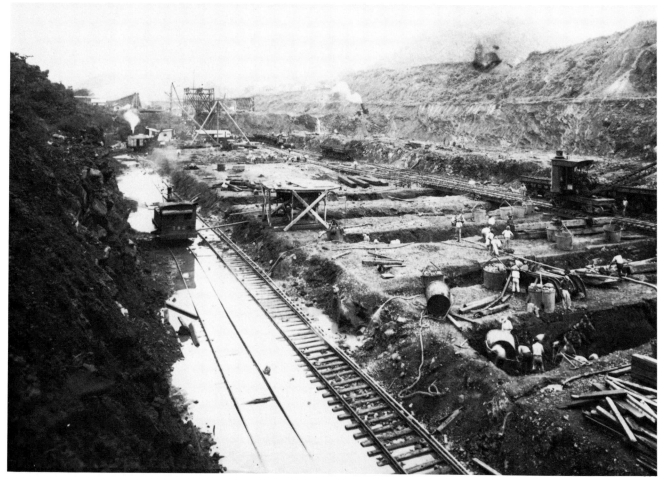

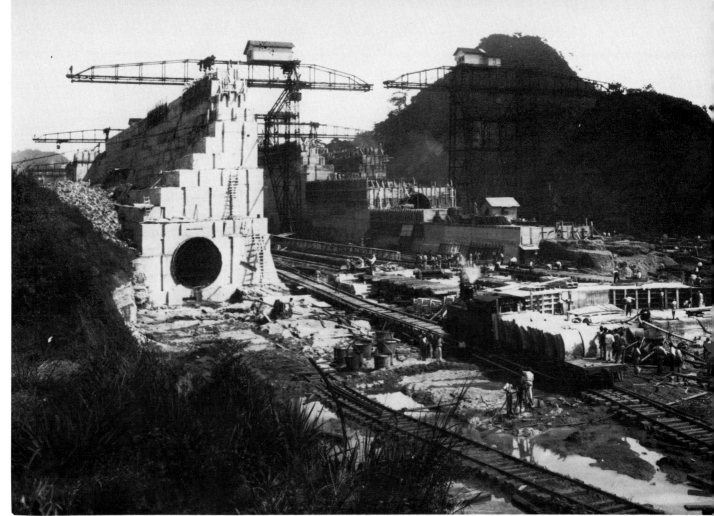

114

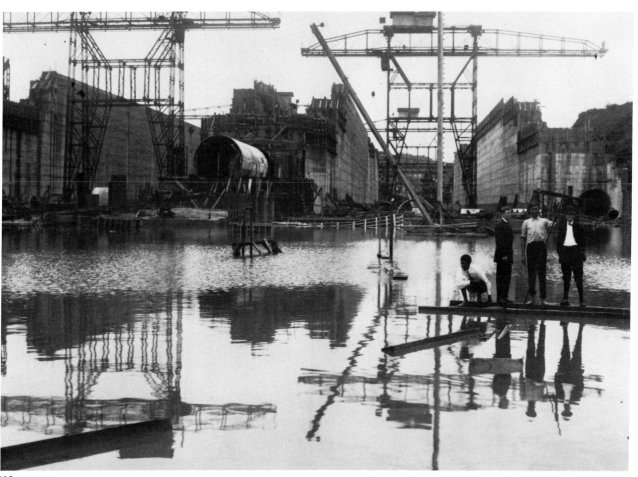

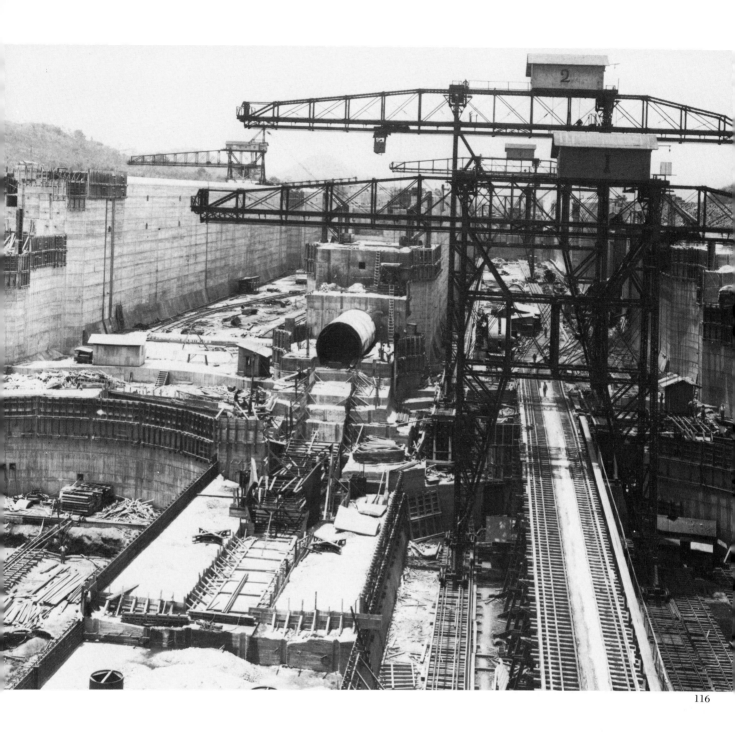

116

116. General view of Miraflores upper locks under construction, March 31, 1912. **117.** Stony gate valve frames in position at east side wall, Miraflores upper locks, January 7, 1911. **118.** Casting concrete slab for towing track on north approach wall, Miraflores upper locks, May 22, 1913.

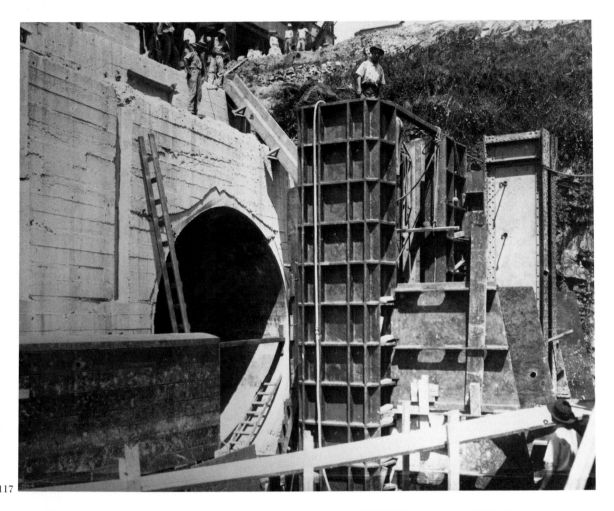

117

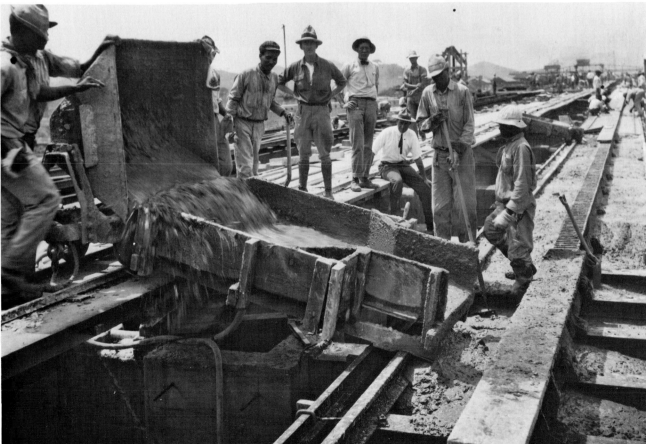

118

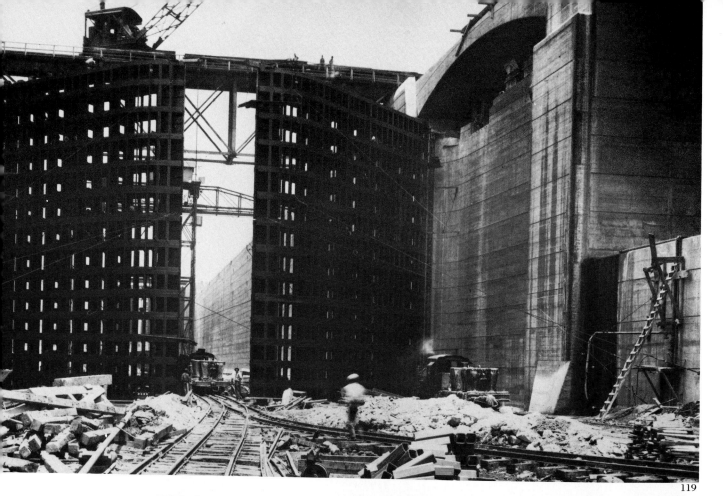

119

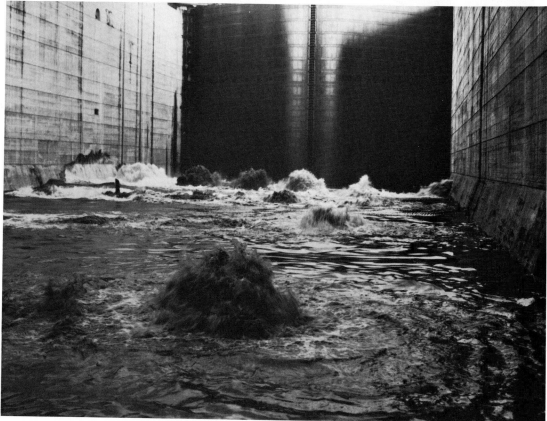

120

119. South entrance to east chamber, showing construction of gates, Miraflores lower locks, April 5, 1913. **120.** First water entering Miraflores upper locks, October 14, 1913. From the main culverts in the lock walls smaller chutes extended to valved openings in the lock floors through which a chamber could be filled within 7 to 15 minutes. In this picture the location of the valves is marked by little fountains.

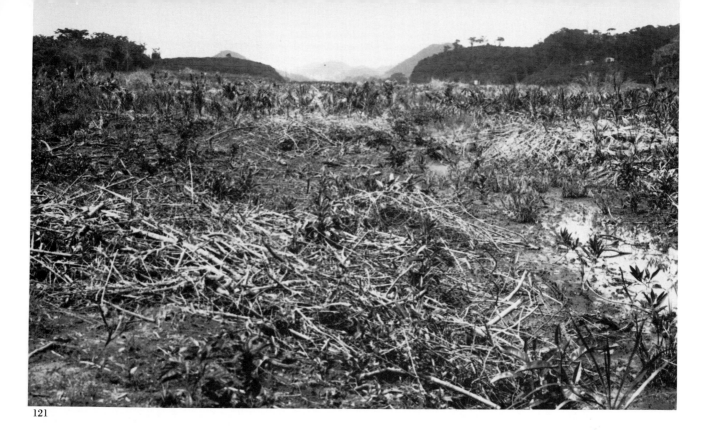

121

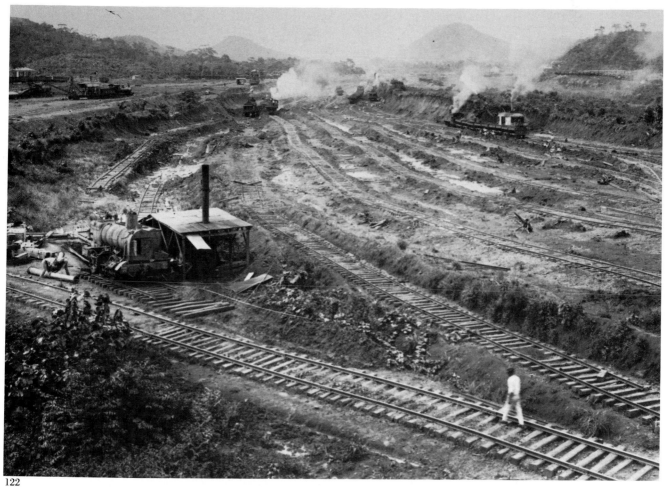

122

From Scratch (nos. 121–124). Clearing and excavating a lock site and erecting concrete lock walls was a long, laborious process. Chief Engineer Goethals made sure that every stage of it was recorded by Ernest Hallen, the Official Photographer, who returned to the principal construction sites at regular intervals.

121. General view of Miraflores lock site, December 1907. **122.** General view of Miraflores lock site, October 1908.

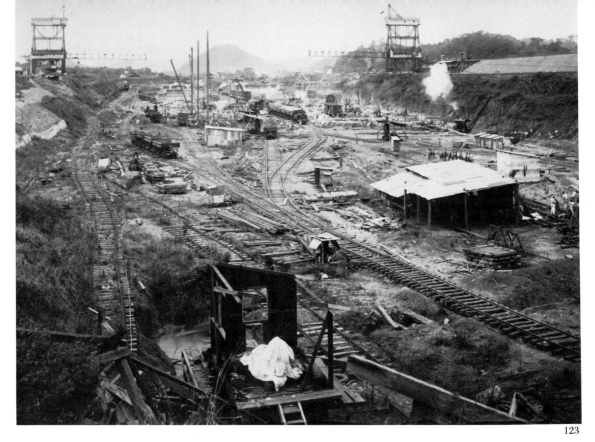

123

123. General view of Miraflores lock site, November 11, 1910.
124. General view of Miraflores lock site, January 21, 1912.

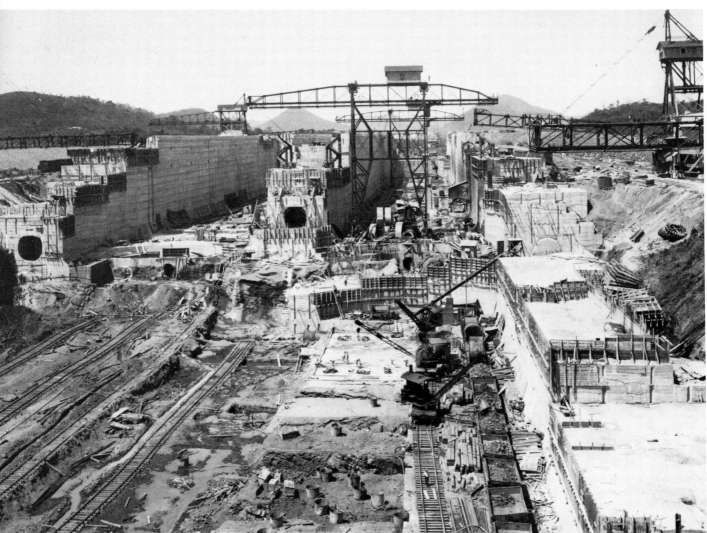

124

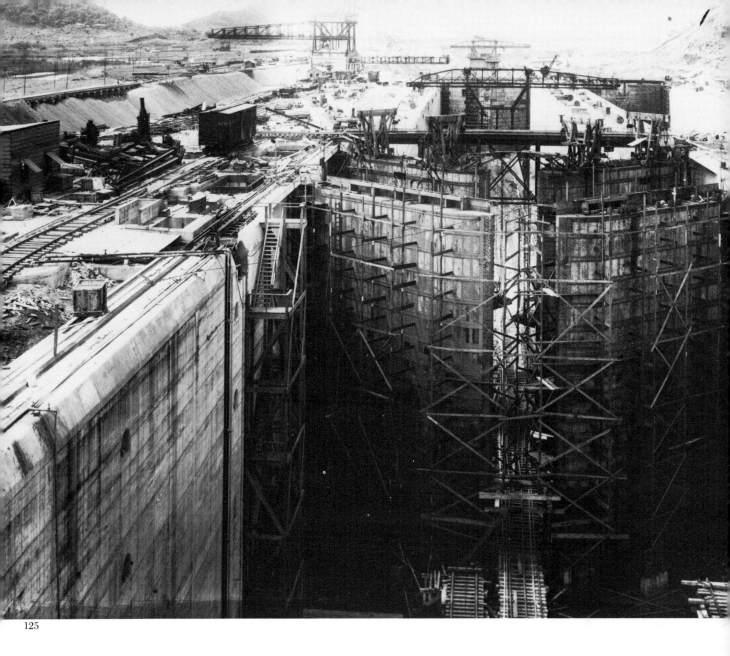

125

Safety First (nos. 125-128). The elaborate safety measures in lock construction included double sets of gates and steel dams that could be swung across the lock in emergency situations. Switchboard operators had a small lock model before them, giving them a miniature version of every move they made. Ships were not allowed to move on their own power, but were pulled by electrical locomotives with 75-horsepower motors and a tractive force of 47,500 pounds.

125. Miraflores upper locks, showing double set of miter gates, July 6, 1913.

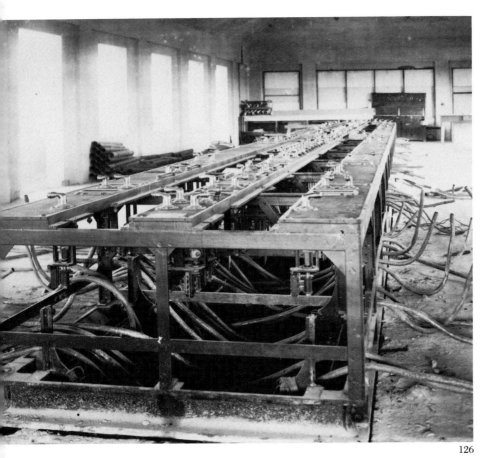

126

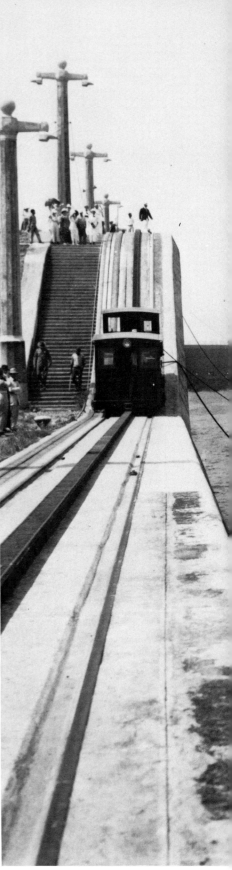

126. Control switchboard at Miraflores locks, ca. 1913. **127.** U.S. *Severn* leaving Gatun locks towed by electrical locomotive, April 15, 1914.

127

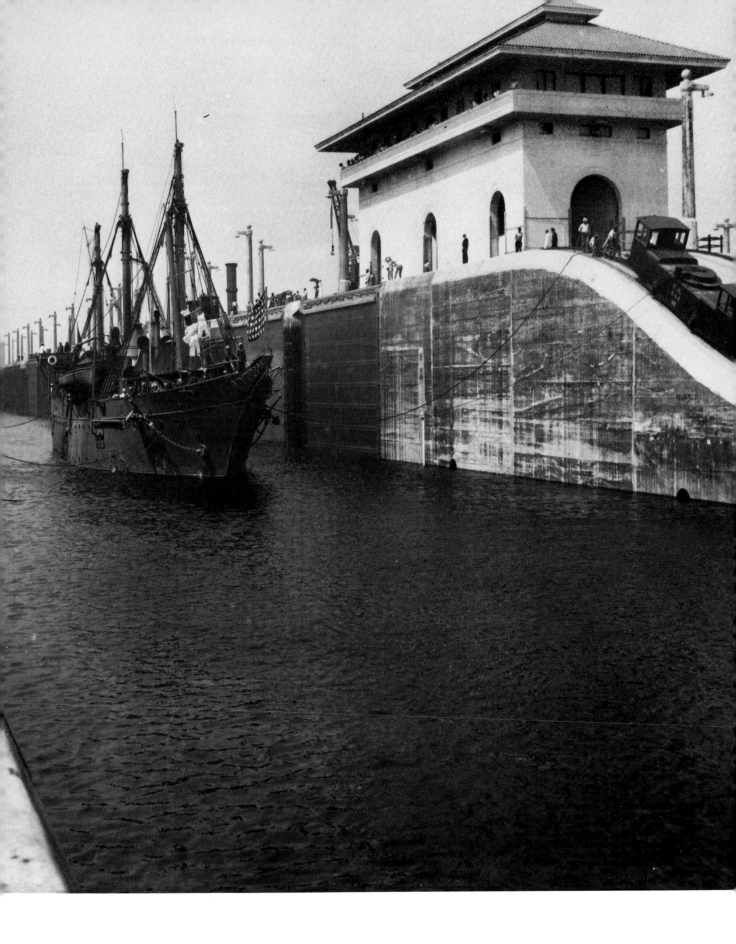

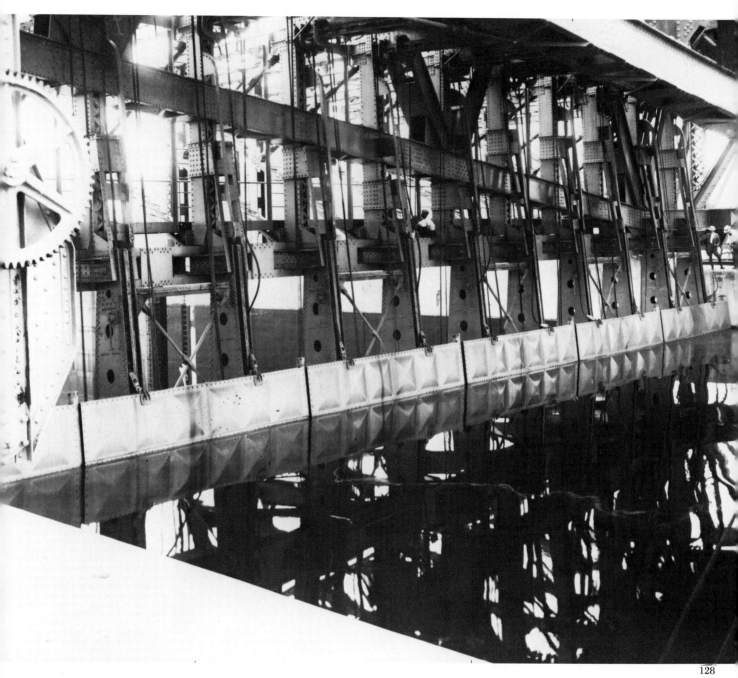

128. Emergency dam across Gatun lock chamber, May 6, 1914.

129

Leisure Time (nos. 129–134). Keeping the canal force happy was essential for smooth progress in construction. Chief Engineer Goethals made sure the Americans did not have to miss traditional amusements, among which baseball claimed top priority. A rich variety of motion pictures and entertainment groups (such as the Four College Girls or the Apollo Concert Company) were brought from the United States. The "dominating social force" on the Isthmus was the Y.M.C.A., which maintained seven clubhouses—complete with library,

dance hall, billiard room, bowling alley, barber shop and a bar for *soft* drinks. Alcohol, gambling and prostitution were not tolerated in the American-ruled Canal Zone, but were close at hand in the autonomous cities of Panama and Colon. A special class of pleasure seekers was the tourists who could study a canal model at the Tivoli Hotel before embarking on their guided tours.

129. Teatime in the private residence of Division Engineer Col. Gaillard and his wife.

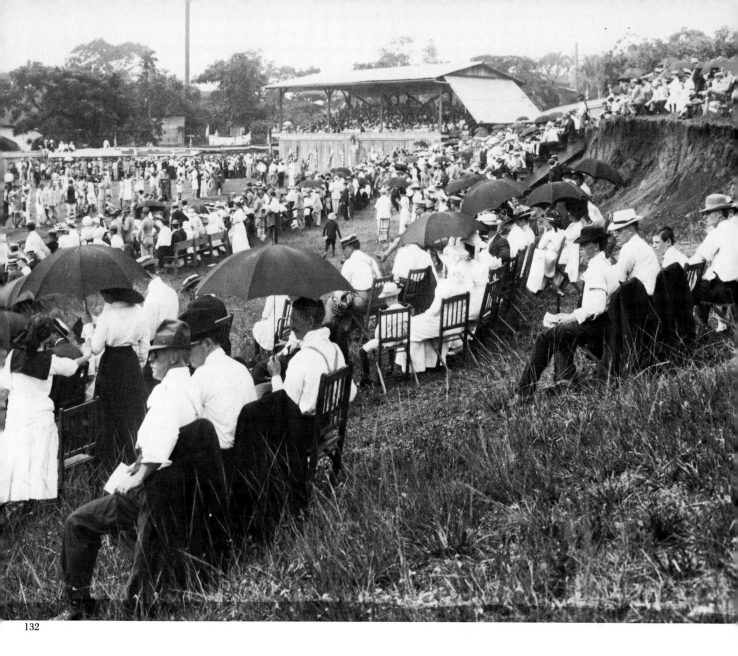

132

130. Patriotic exercises at Cristobal, July 4, 1911. Col. Goethals addresses the employees. **131.** I.C.C. band at the Culebra Club House, 1909. The band gave regular concerts in several Canal Zone towns. Special trains were available for employees who wanted to attend the concerts. **132.** Visitors at Ancon Baseball Park, July 4, 1912. The I.C.C. encouraged baseball in every way, furnishing grounds, special trains and practice opportunities.

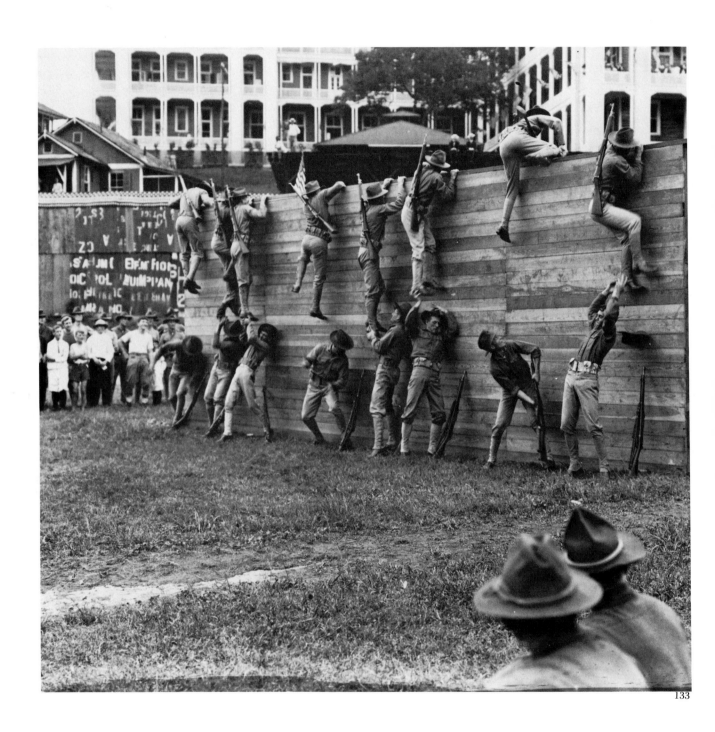

133

134

133. U.S. Marines scale a wall in an athletic meet at Ancon Baseball Park, July 4, 1912. Col. Goethals regarded the Panama Canal mainly as a military object, but Congress did not agree and allowed only a modest American military presence on the Isthmus. **134.** Reading room in the Y.M.C.A. clubhouse at Culebra, 1909. An average of 3255 books were drawn every month by 1117 library members.

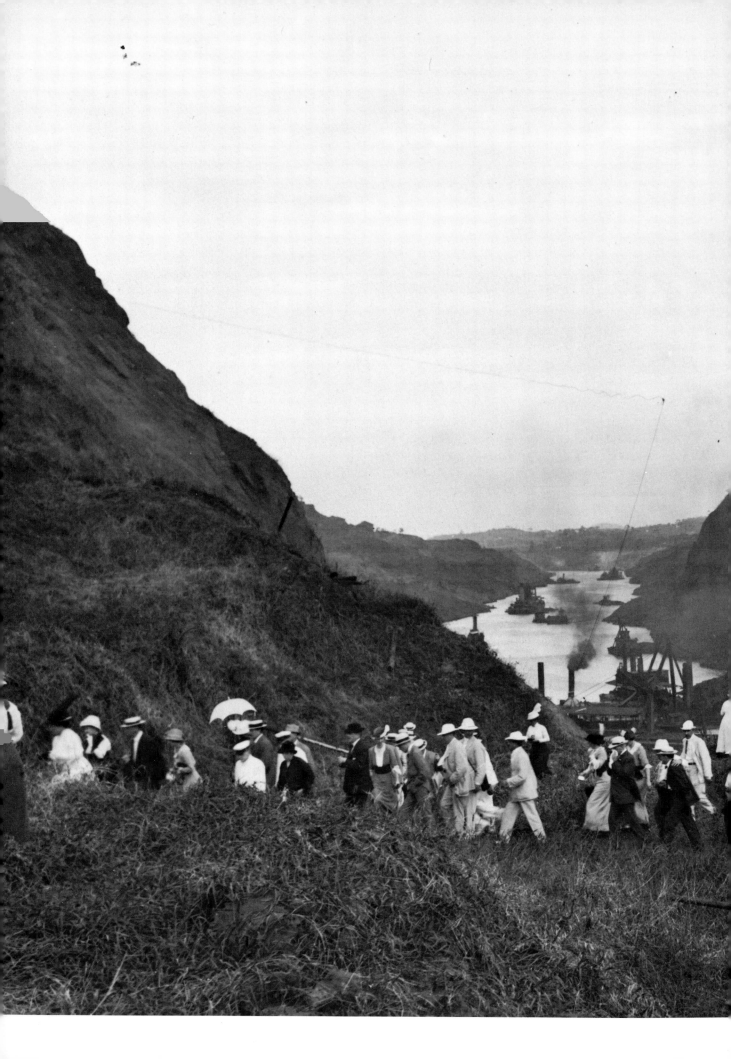

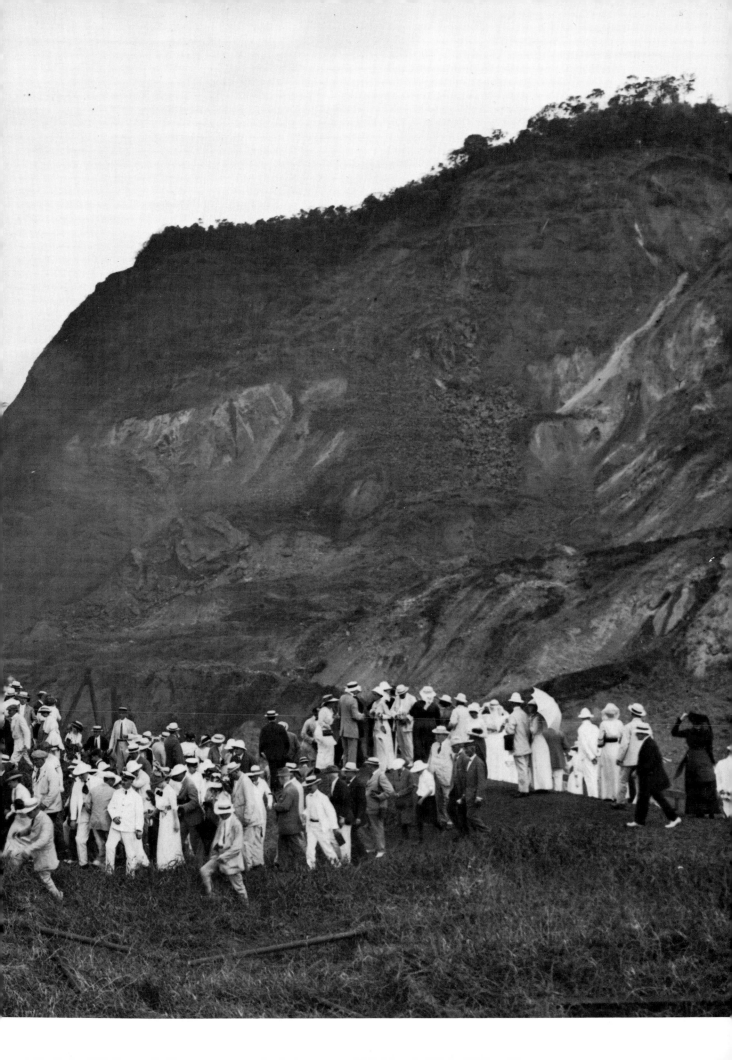

136

137

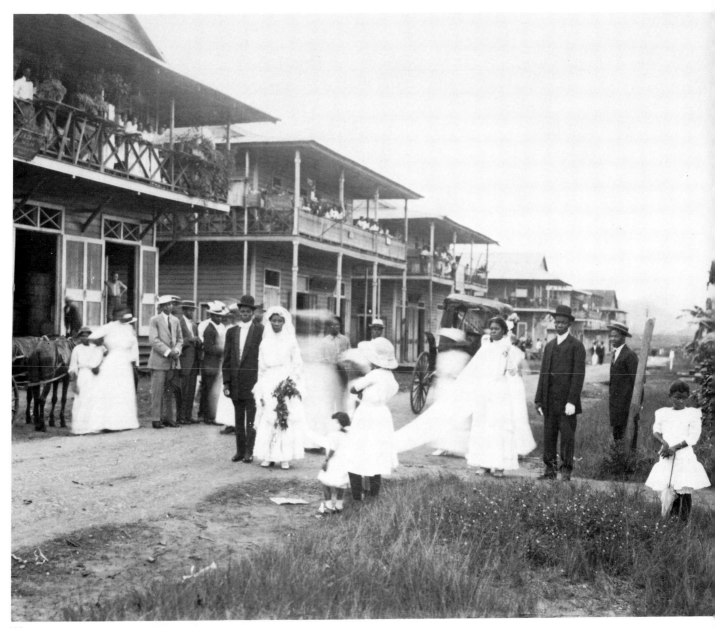

138

Sightseeing (nos. 135–138). Tourism on the Isthmus developed into a major phenomenon. In 1913, from January to June, 20,000 visitors were counted. Popular excursion destinations included Cucaracha Slide (a mud slide at Culebra Cut), native villages and historical monuments. Tourist accommodations at the Tivoli and Washington Hotels were considered highly comfortable and extremely expensive.

135 (preceding spread). Tourist party viewing Culebra Cut and Cucaracha Slide, February 21, 1914. **136.** Christopher Columbus statue in front of Washington Hotel at Colon, 1916. The statue was a gift of the French government. **137.** Reading room in the Tivoli Hotel at Ancon. **138.** West Indian wedding party at Culebra, 1913.

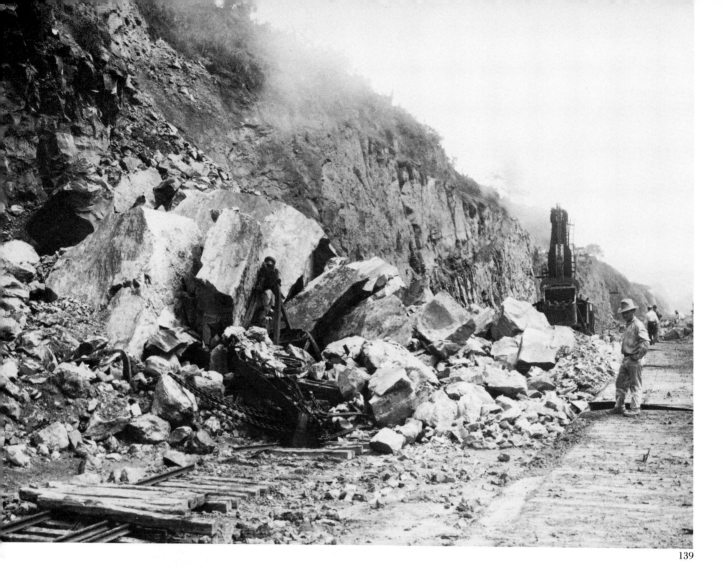

139

94

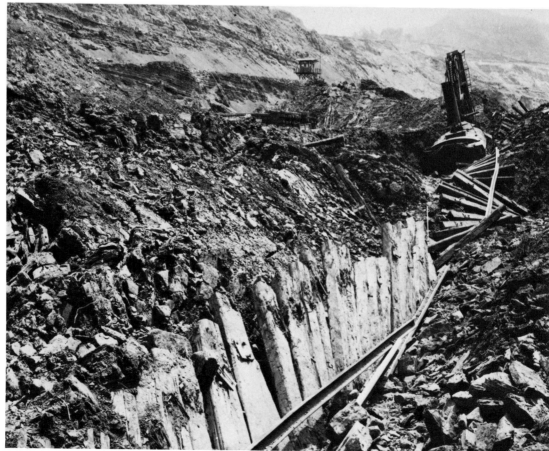

140

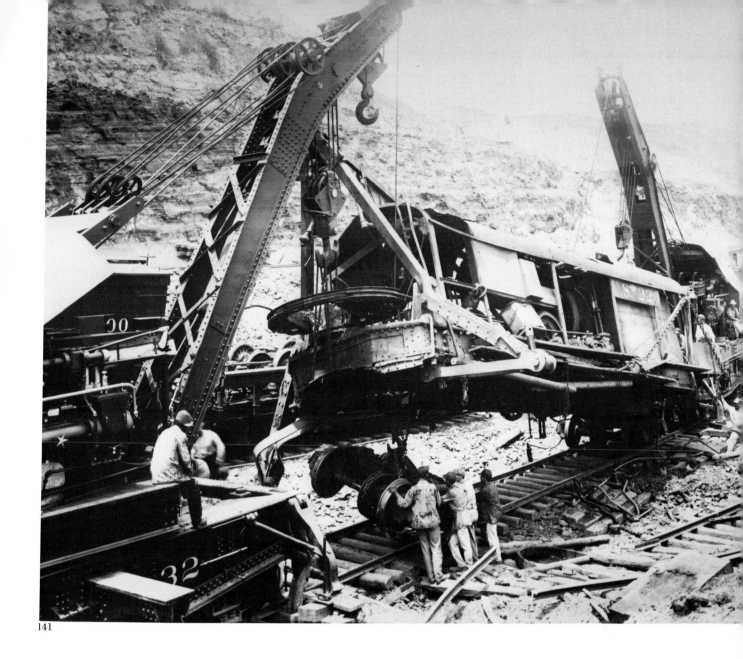

141

Frustration (nos. 139–145). As work progressed in Culebra Cut the Americans encountered a formidable and frustrating obstacle: huge landslides that added 32 million cubic yards to the volume of excavation, buried or destroyed several hundred miles of tracks and delayed completion by two years. According to the original plans, the Cut was to be 670 feet wide at the top. After 300 acres of earth and rock had thundered down the slopes, the top width exceeded 1800 feet. Cucaracha Slide, the worst of all, kept moving for decades, and was once described as a "tropical glacier—of mud instead of ice." No method of coping with the slides was ever discovered—except patiently digging them out whenever they occurred. In the final months, Chief Engineer Goethals flooded the

Cut since the weight of the water counteracted the slides and dredging proved cheaper than shoveling.

139. Steam shovel 218 buried under a fall of rock, Culebra Cut, Las Cascadas, May 31, 1912. Rock slides such as this one (in which nobody was hurt) were negligible in size, but dangerous because they occurred without warning. Most big mud slides moved at a slow and predictable pace of 10 to 15 feet per day. **140. Break in the east bank of Culebra Cut engulfing steam shovel 201, February 7, 1913.** Miraculously, nobody was killed in the slides until May 1913, when four West Indians lost their lives near Gold Hill. **141. Break in the east bank of Culebra Cut, March 13, 1913.** Wreckers put steam shovel 220 back on track.

95

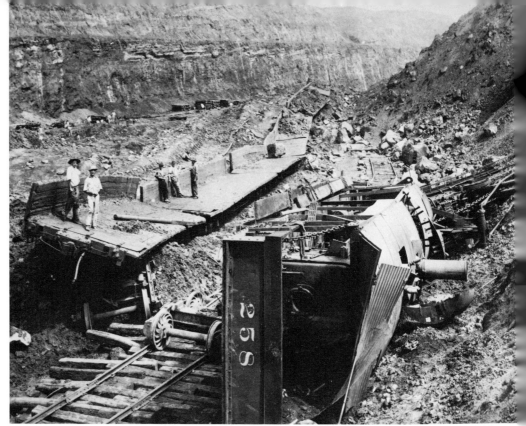

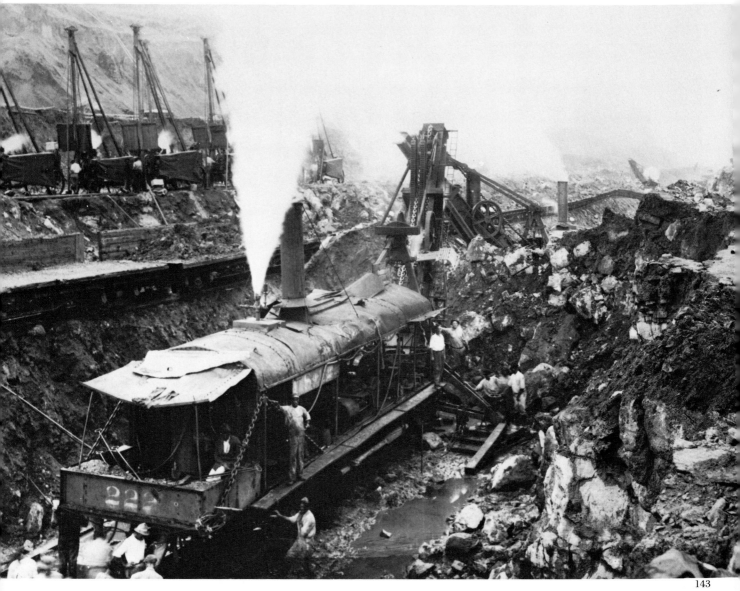

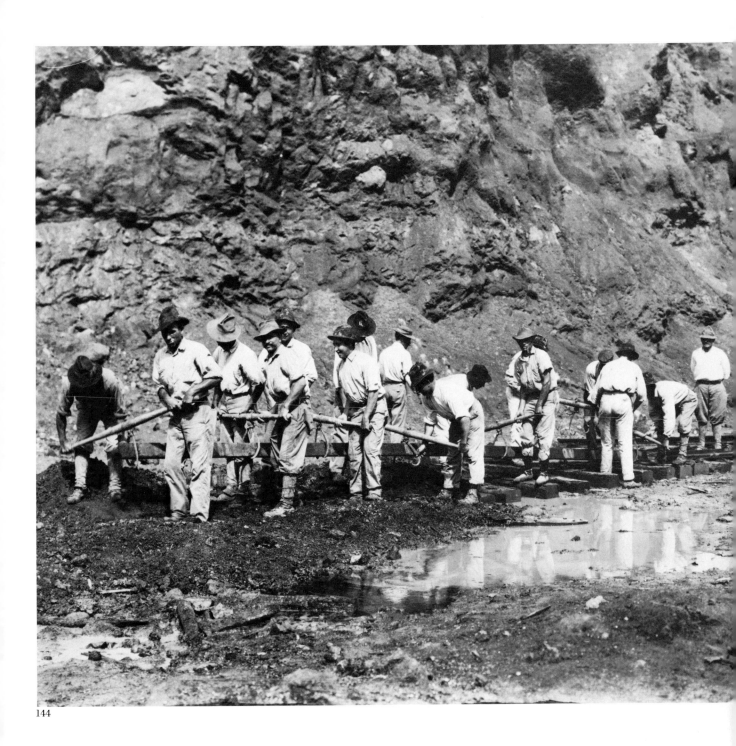

144

142. Break in the east bank of Culebra Cut with the wreck of steam shovel 258, May 29, 1913. 143. Completion of bottom pioneer cut in Culebra Cut, May 20, 1913. As the *Canal Record* proudly announced on this day: "Steam shovel 222, manned by J. S. Kirk, engineer, and U. L. Hill, craneman; and steam shovel 230, manned by D. J. McDonald, engineer, and J. V. Rosenberry, craneman, met at Canal grade about 4:30 P.M." 144. Spanish laborers remove tracks from Culebra Cut before it is flooded, September 4, 1913.

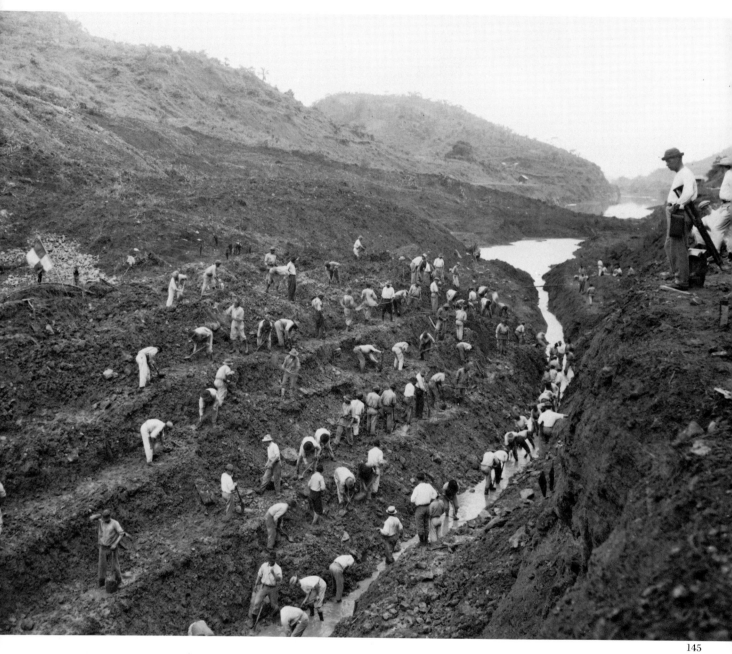

145. Laborers dig a ditch around the toe of Cucaracha Slide, October 11, 1913. This slide occurred after the railway network had been removed from Culebra Cut. Consequently the slide had to be excavated by hand.

Slide Mechanics (nos. 146–149). There were two kinds of slides. Gravity slides (such as Cucaracha) were caused by heavy rains that separated the mud from underlying rock formations and sent it down the valley like snow off a roof. Structural break slides (such as West Culebra) occurred when too much weight pressed down on the lower strata of the canal slope, forcing the strata to break out laterally into the canal bed. Even granite was known to crumble under such pressure.

146. An unsuccessful attempt to blast a channel through the Cucaracha Slide, October 16, 1913. **147.** West Culebra Slide seen from Gold Hill, June 1917.

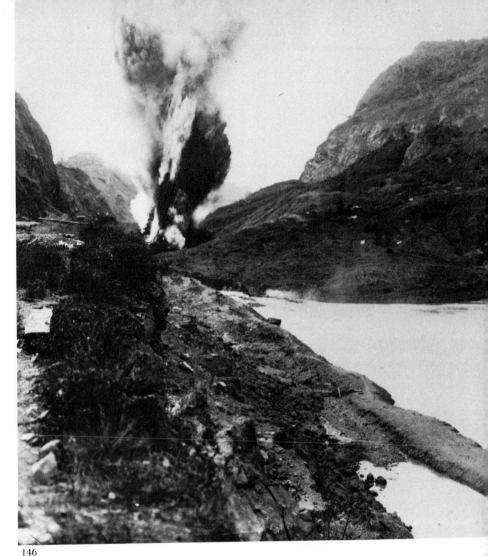

146

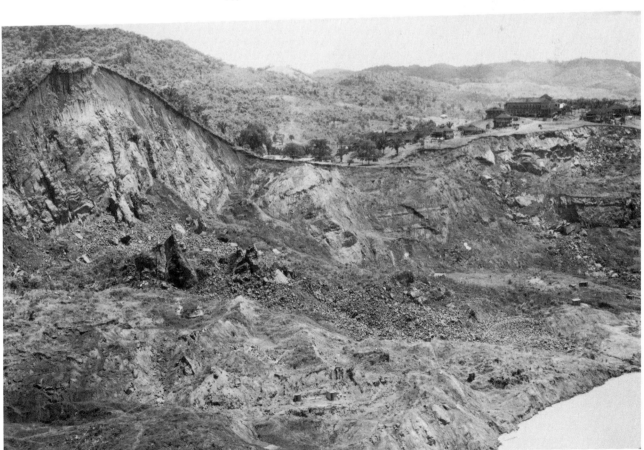

147

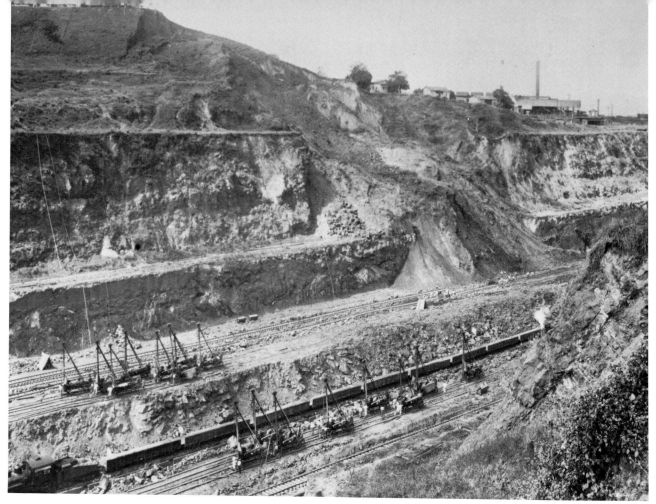

148. Gravity slide on the west bank of Culebra Cut, near the town of Culebra, January 6, 1913. **149.** Break in the east bank of Culebra Cut, September 19, 1912.

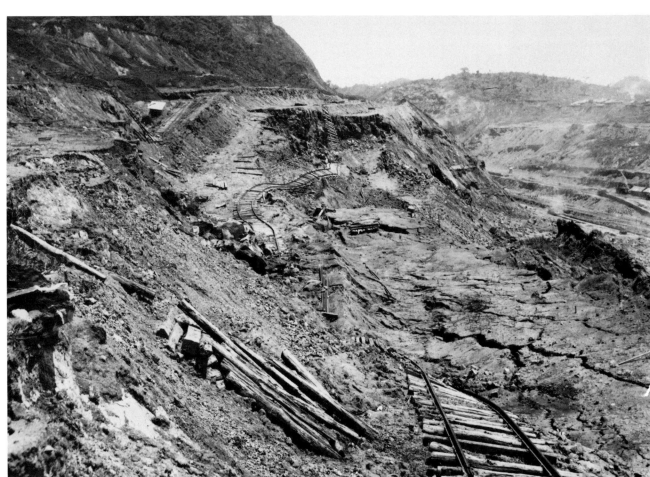

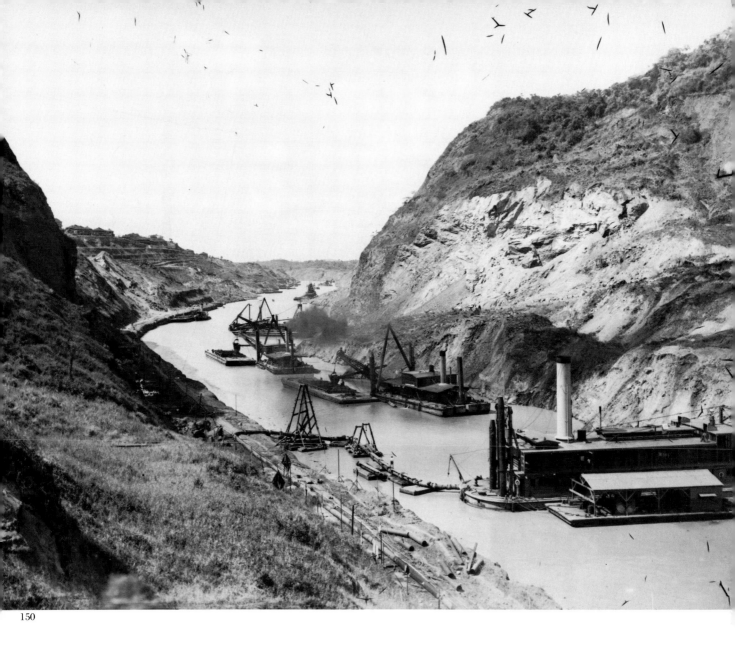

150

The Dredging Fleet (nos. 150–153). Basically, three types of dredges were used in canal excavation. Suction dredges featured a revolving cutter that loosened the earth material so that it could be removed through a suction pipe. The huge Bucyrus dipper dredges had dippers with a volume of 15 cubic yards (the length of 34 men standing side by side). The ladder dredge *Corozal* was fitted out with a 115-foot-long chain of buckets holding 54 cubic feet each.

150. Dredges at work in Culebra Cut, January 28, 1914.

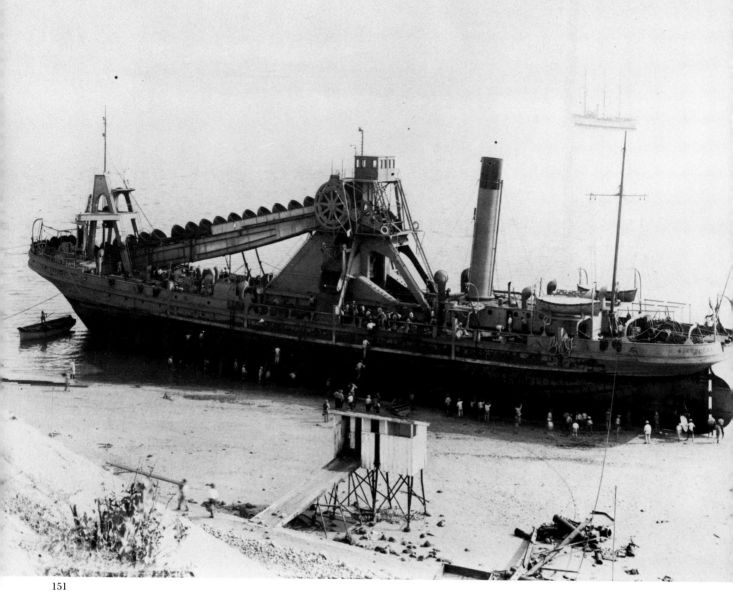

151

151. Ladder dredge *Corozal* beached on Naos Island, June 1912. 152. Dipper dredge *Gamboa* operating in the Gold Hill slide, January 19, 1915. 153. U.S. suction dredge 84.

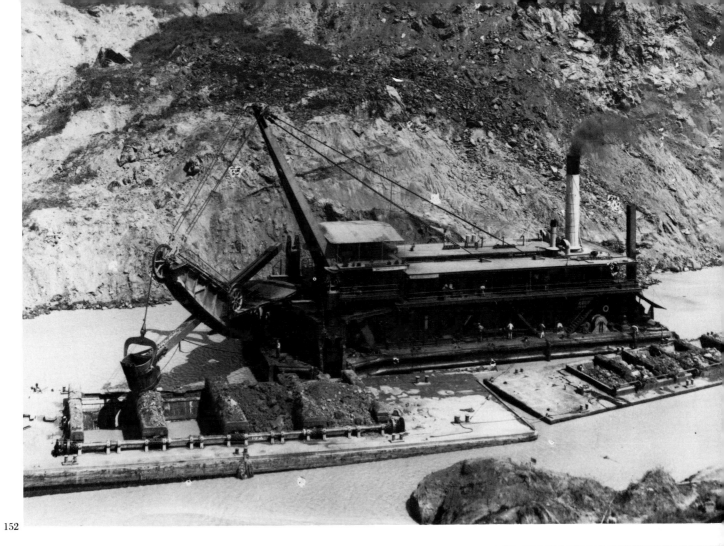

152

153

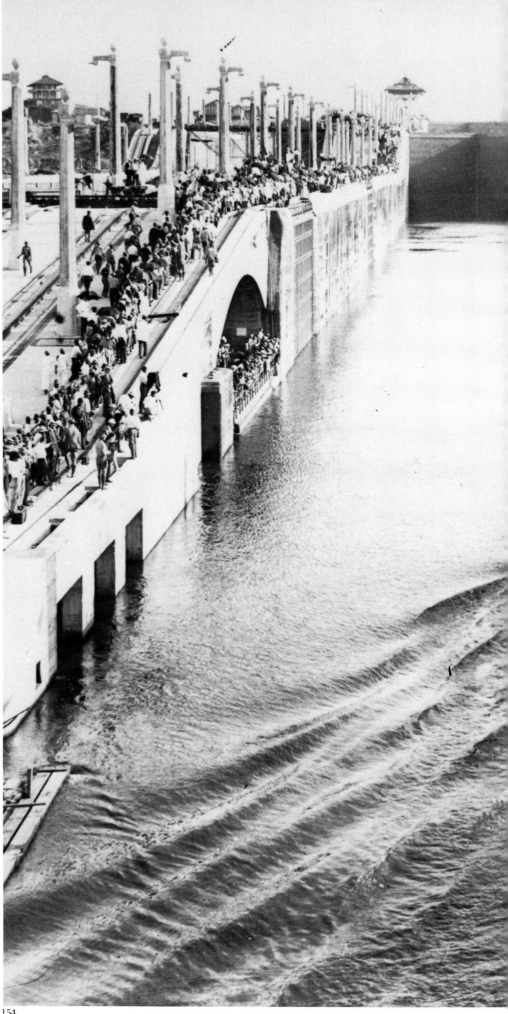

154

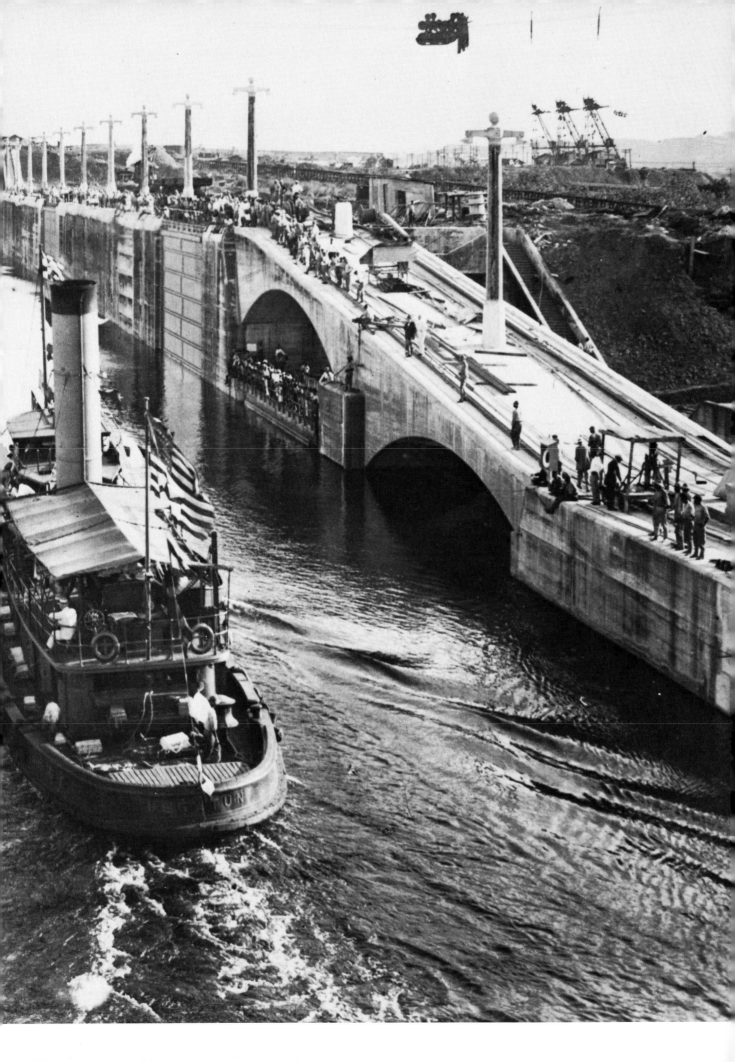

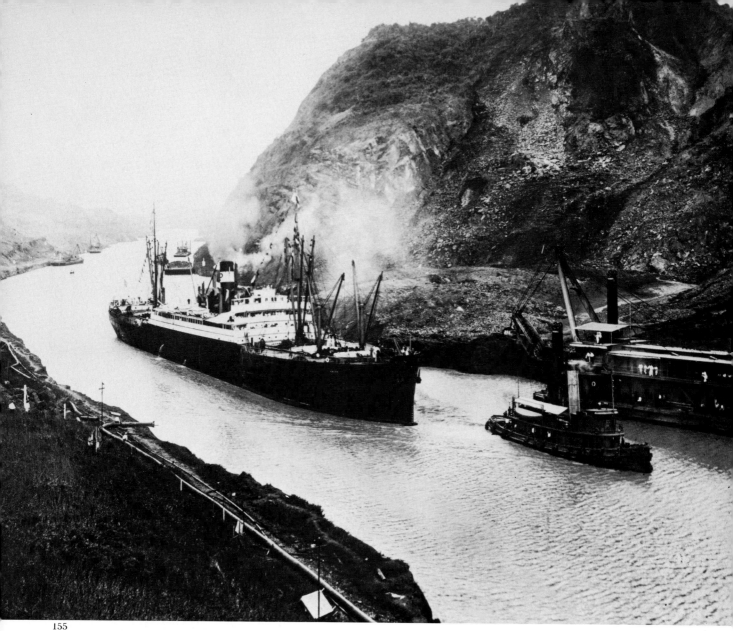

155

Victory (nos. 154–157). In spite of the grave problems at Culebra Cut the canal was completed slightly ahead of the ten-year schedule envisioned when work was begun in 1904. Altogether, 232 million cubic yards were excavated, $352 million expended and 5609 lives lost. When the canal was opened on August 15, 1914, Chief Engineer Goethals received an official cable from Washington summing up what many Americans felt: "A stupendous undertaking has been finally accomplished, and a perpetual memorial to the genius and enterprise of our people has been created." Since the First World War had broken out a few days earlier, however, the inauguration was rather anticlimactic. Among the few guests no important political figure was included. A naval parade had to be postponed until July 25, 1919. On that day, the American Pacific fleet passed through the canal in a

solemn procession that would have made Teddy Roosevelt proud had he lived to see it.

154 (preceding spread). First boat through Gatun Locks, September 26, 1913. At 4:45 P.M. the seagoing tug *Gatun* steamed into the lower lock "with flags flying and whistle blowing, accompanied by the cheers of the assembled spectators," as the *Canal Record* reports. **155. Opening of the Panama Canal: S.S. *Ancon* passes Cucaracha Slide, August 15, 1914.** "The complete trip from the ship's berth at dock 9, Cristobal, to the end of the dredged channel, five miles out in the Bay of Panama, was made in approximately nine hours and 40 minutes," according to the *Canal Record*. **156. Fifteen-yard dipper dredge at work in Culebra Cut, November 16, 1915.** In September 1915 an enormous mud avalanche bottled the canal up for seven months. Like all previous slides, it was overcome by patient digging. **157. The Pacific fleet passes through the Panama Canal: U.S.S. *Texas* in Gatun Locks, July 25, 1919.**

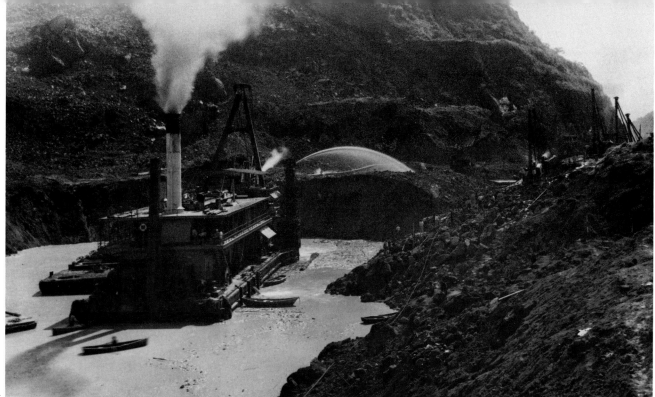

156

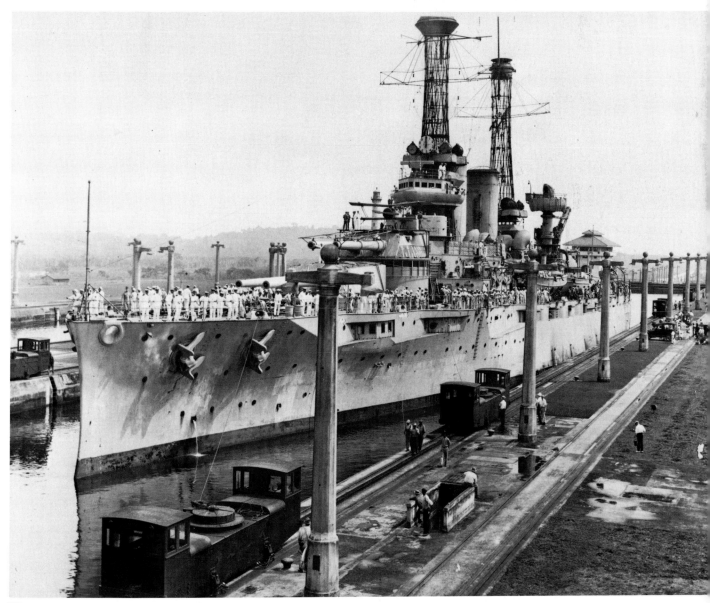

157

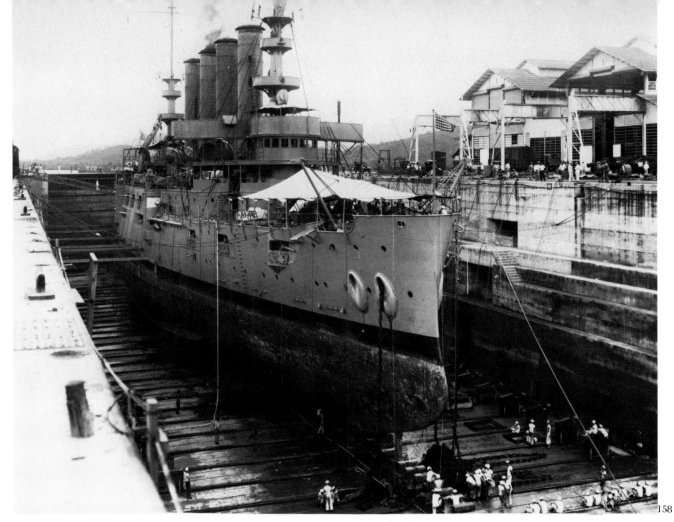

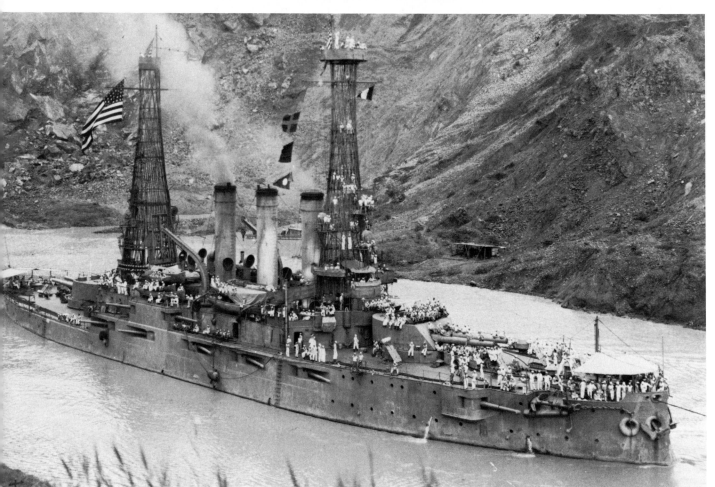

U.S. Navy Presence (nos. 158–161). While the Panama Canal's military importance remained secondary to its commercial significance, the U.S. Navy always could count on preferential treatment in the locks and docks.

158. U.S.S. *Charleston* in dry dock 1, Balboa, September 8, 1916. **159.** U.S.S. *Ohio* passes Cucaracha Slide, July 16, 1915. **160.** U.S.S. *Bittern* and the German submarine U.B. 88 in Pedro Miguel locks, August 12, 1919. **161.** U.S.S. *Saratoga* in Miraflores locks, June 11, 1930.

160

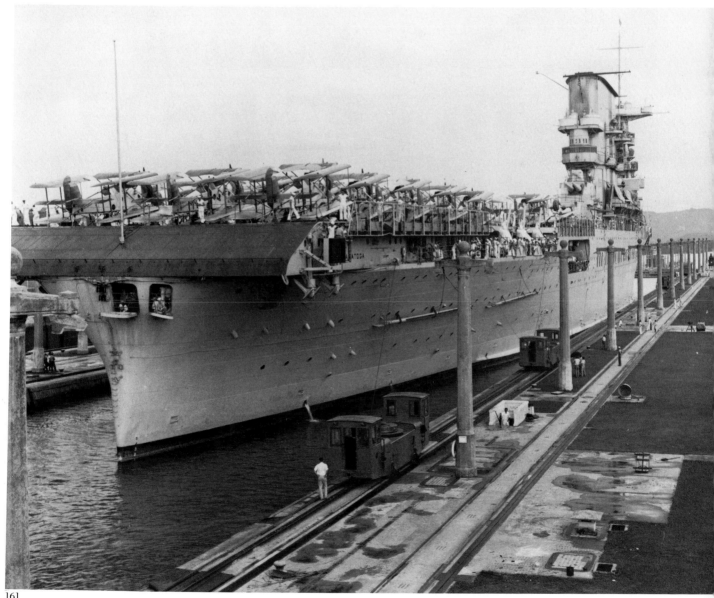

161

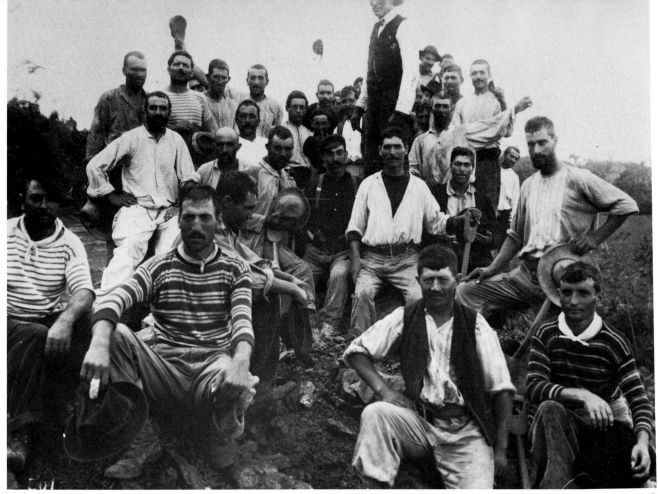

162

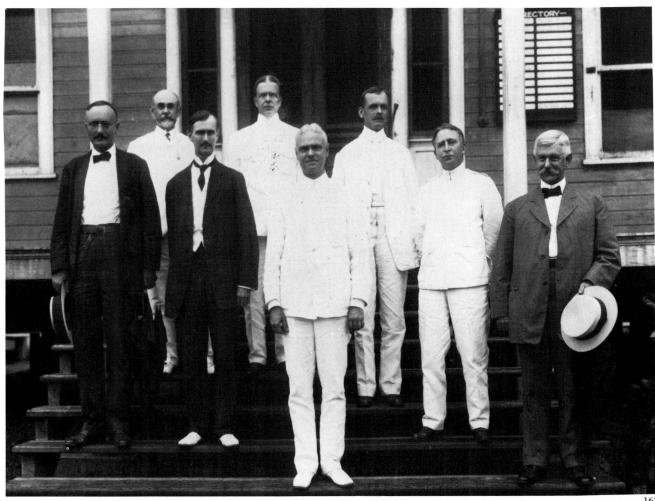

163

164

"A Stupendous Undertaking" (nos. 162–164).

162. The men who built the canal: a group of Italian laborers on a dirt train. **163.** The men who built the canal: the Isthmian Canal Commission, August 25, 1910. From left to right: W. L. Sibert, J. B. Bishop, M. H. Thatcher, H. H. Rousseau, G. W. Goethals, D. Gaillard, H. F. Hodges, J. Gorgas. **164.** The Land Divided—The World United. The official seal of the Panama Canal Zone.